Voices of America

Growing Up in St. Francois County

Voices of America

Growing Up in
St. Francois County

BONNE TERRE AND THE ST. JOSEPH LEAD COMPANY

Compiled by
Jim Bequette

ARCADIA
PUBLISHING

Copyright © 2001 by Jim Bequette
ISBN 978-0-7385-1904-3

Published by Arcadia Publishing
Charleston SC, Chicago IL, Portsmouth NH, San Francisco CA

Printed in the United States of America

Library of Congress Catalog Card Number: 2001091667

For all general information contact Arcadia Publishing at:
Telephone 843-853-2070
Fax 843-853-0044
E-mail sales@arcadiapublishing.com
For customer service and orders:
Toll-Free 1-888-313-2665

Visit us on the Internet at www.arcadiapublishing.com

CONTENTS

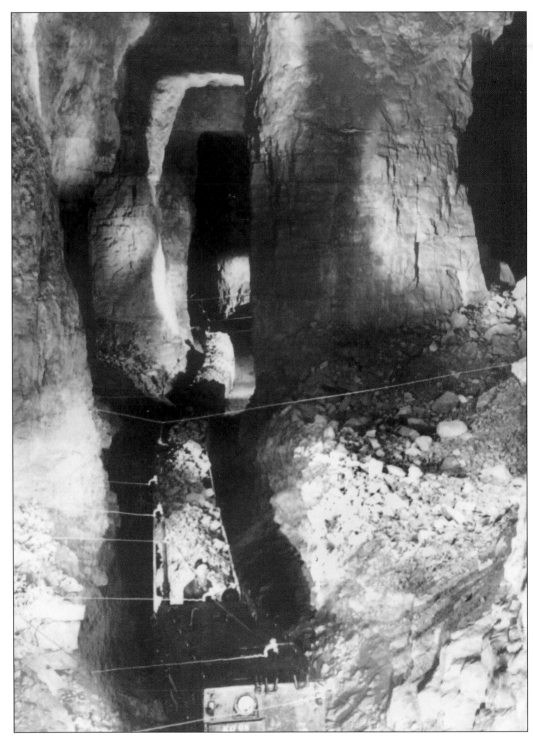

This is a typical underground scene at Bonne Terre in the 1950s and until 1961. Train pulling ore cars. (Courtesy of Doe Run Corp.)

AUTHOR'S FOREWORD

Town square is shown here as it appears today. The parking lot in the foreground is where a bank building once stood. The single story building on the extreme left is where the movie house had been.

Diamond drill. Headframe. Jig. Cornish rollers. Those words hold little meaning to most people. A dictionary would not offer much help. To me, however, the words became part of my daily vocabulary shortly after I learned to speak. More importantly, I knew what they meant. They were very much a part of life where I happened to be born and reared—a small dot on the map identified as Bonne Terre, Missouri.

A translation from French into English explains Bonne Terre as "good earth." During my first 20 years of life there, a large white sign with green lettering and matching lattice work greeted visitors as they first entered town. Simple but direct, it read:

WELCOME TO BONNE TERRE:
GOOD EARTH—GOOD PEOPLE.

Pompous as that might sound, I hold it to be true.

I had a terrific time growing up. Naturally, much of that pleasure I attribute to family: parents, grandparents, aunts and uncles. To stop at that point would be negligent of me. Equally important were the lead company and the town itself. Together, all those entities brought into being the nearest thing to an ideal childhood I might imagine. The period in which I lived there—1946 through 1966—might have been the eminent time for us all: city, company, individual.

Leaving the comfort and security of my hometown came not by choice but by pressure. American military activity in Southeast Asia had draft boards frantically seeking healthy young men. I happened to qualify. I had foolishly skipped one semester of college to help reconstruct a golf course in Farmington. President Johnson apparently heard of my eligibility and had the draft board invite me to help defend our nation. I held nothing against this country of ours. Truthfully, I had every intention of offering my services voluntarily, at a time of my own choosing. Furthermore, olive green did not appeal to me as a flattering color. I preferred blue, the same shade as worn by those in the Air Force. Thankfully, when the invitation arrived I was once again a full-time college student. This allowed me to obtain a deferment, but only for the remainder of that one semester. When the deferment became official I hurried to the local Air Force recruiter, signed up for a four year hitch, and could finish out that term.

Anxious to obtain my services, the Air Force insisted I leave for basic training in San Antonio, Texas, only one day after final exams. Four weeks later they presented me with orders and transportation to Plattsburgh, New York. Having barely enough time to get situated and learn what expectations the military had for me, a fellow squad member stopped by my desk to introduce himself. Completing the formalities of hand shaking and an exchange of our names, he casually inquired as to where I called home. "Missouri," I quickly answered, seeing no need to be more specific. He glared at me, then broke into a sly smile. "I heard it was Missouri, but where in Missouri?" he insisted. "Bonne Terre," I responded in a soft tone. With intention, I studied his face. I expected to see wrinkles form on his brow and a hard squint around both eyes. The next question I anticipated from him was wanting to know exactly where that flyspeck of a town might be located. Instead, he offered a broad grin which stretched from ear to ear. "That's the nicest little town I've ever been in," he stated with sincerity. Overwhelmed, those wrinkles and squint I had expected to form on his face suddenly appeared on my own. He detected my stunned disbelief. Before I could take a breath, he continued with, "Don't believe me, huh?" He said it more like a dare rather than a real question. An index finger went straight to his chin and tapped out a steady tempo for many seconds while he thought. With both eyes nearly closed as he visualized something in his mind, he finally spoke again. "I know there's a movie house on one corner at the town square. I've been there lots of times. A bank is across the street. Over on another

The restaurant housed the most popular drugstore and grill in Bonne Terre.

corner is a drug store where they make great burgers." There came a slight pause, he started to speak but checked himself, then paused again before saying, "Darn if I can think of what's on the other corner."

By then I had nearly slipped from my chair and onto the hard, tiled floor. "A shoe repair shop," I managed to suggest in the form of a reminder.

"That's it," he blurted, followed with a loud snap of his fingers. "Don't know how I could ever forget that smell of leather."

It so happened that a great-aunt of his had lived in my hometown for many years. He visited her twice, each time for a week. That incident only proved to be the first of similar contacts I would encounter with people who either had heard about the town or had passed through it for some reason or other. On the other hand, not many people had heard of the world's largest lead company, St. Joe. They knew of Hallmark Cards in Kansas City, or McDonnell Douglas, Ralston

Purina, and Anheuser-Busch in St. Louis, but little or absolutely nothing of St. Joseph Lead in Bonne Terre.

My appreciation for Bonne Terre and the lead company only strengthens with the passing of time. Not many years ago publicity of a negative kind brought attention to the entire Lead Belt and the former mining firm. Environmental concerns over lead poisoning captured headlines of all media sources. I laughed myself silly more than once while reporters in somber voices stressed the dangers likely to exist in St. Francois County. Not that I find humor in the terrible illness but I saw a great irony conveniently overlooked by reporters whom we are to trust. Our water source for decades had come directly from the mines. It then flowed through lead pipes into our homes and out through taps. Our daily consumption of water in those days is comparable to soft drink consumption today. Most of our houses had layer after layer of lead based paint both on the exterior and

interior. Not once do I recall a case of lead poisoning reported in Bonne Terre. In fact, people generally seemed to live long, healthy lives.

My family connection to St. Joe and the city of Bonne Terre date back to 1882. Many family members devoted their working careers to the lead company. One great-grandfather served as a miner, another as master carpenter. A grandfather worked as a supply assistant. My father hired on as an accountant. And, my step-father eventually became Division Manager/Vice President of the firm. Each one gave over 40 years of dedicated employment to St. Joe which means I was privy to a great amount of information. Some of what I heard was insignificant. Some was confidential. All was quite interesting. Because I possess some stories from a wide array of sources, I want to share many of them, along with my own recollections about the town and company.

Aware how easy it might be to get carried away and wax romantic, I vow to be fair. The entire realm will be presented which includes the good, the bad, and the ugly. Thankfully, not much of the latter two existed, but what I know will be told without restraint.

It will be noted that names of individuals are not mentioned. This is intentional. Any attempt to identify people could lead to problems. Forgetting to mention a family or just one individual might offend the fine folks I intend to dignify. That is the only liberty I promise to take.

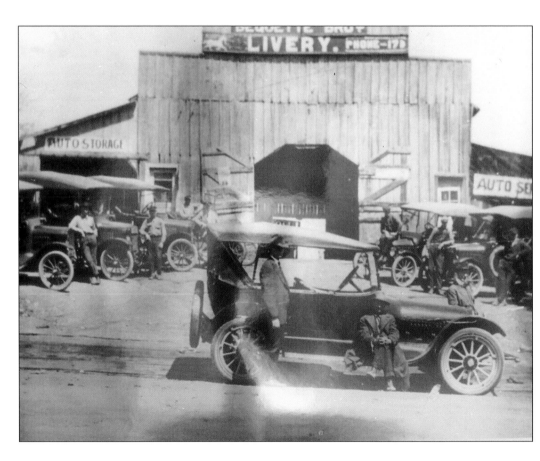

The author's family not only worked for the lead company, but operated this livery stable for many years. (Courtesy of Doe Run Corp.)

Chapter 1

BIRTHING OF A TITAN

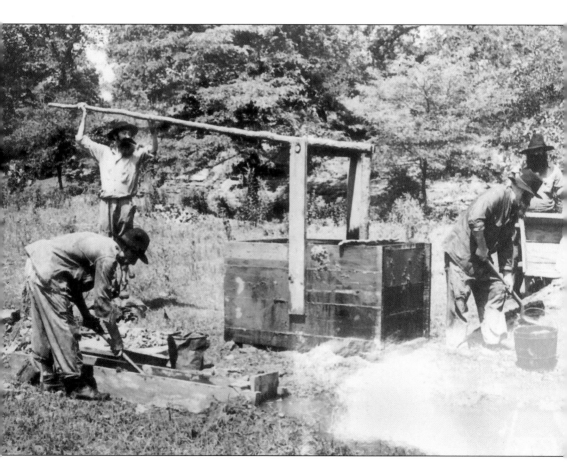

Pictured here is the crude process of ore washing prior to minerals being ready for the smelter. (Courtesy of Doe Run Corp.)

In 1673, Father Marquette and Louis Joliet paddled southward down the Mississippi River. Afraid there could be life-threatening danger from savage Indians the further they traveled, the two men called a halt at the Arkansas River, turned around, and paddled back upstream. Throughout that burdensome trek they maintained detailed journals of what they found. Not only did they describe observations from along the waterway but also their findings in interior sections as well. In regard to the area destined to later become southeastern Missouri, their reports spoke glowingly of vast mineral deposits. That news, coupled with the fact that Native American locals tended to be friendly, sparked immediate interest.

Early-18th-century French explorers confirmed Marquette and Joliet's findings. While some continued to probe deeper into uncharted areas, others remained to stake mineral claims. Many of the latter category managed comfortable livings operating small mining concerns supplemented by trapping animals for hides. Historians inform us that galena, or lead sulfide, literally sprang from the ground like stubby tree trunks. The manner used to garner deposits above or barely underneath the soil is called surface mining.

From those earliest known beginnings and continuing until the outbreak of our Civil War, numerous mining camps flourished in southern parts of Missouri. War changed all that. Men dropped their hammers, pry bars, and shovels to join the conflict. Some went North, some South, and still others joined vigilante groups such as Sons of Liberty or Knights of the Golden Circle. Lacking adequate workers, most mining operations ceased. The very few which continued soon found trouble. One army or the other would burst into camps sending workers fleeing for their lives. Equipment got smashed, confiscated, or both, causing any renewal of activities to be nearly impossible.

By the close of 1863, however, most military action seemed concentrated well east of the Mississippi River. Stability of pre-war days reappeared in eastern and southern portions of Missouri. At that same time, a group of Yankee investors in New York City obtained information regarding the mineral riches of this state. With logic informing them that great sums of money could be made quite easily, and with the abatement of war from this region, they determined to make a financial investment. They filed papers of incorporation on March 25, 1864. The name of their new venture would be the St. Joseph Lead Company.

The group wasted no time. On May 2nd, they purchased 946 acres of land in St. Francois County, State of Missouri. Two notes were signed for this transaction totaling a preposterous sum of $75,000. Somehow, a manager was immediately hired, and he secured enough workmen in the area to commence mining. The same old method of surface mining and crude system of crushing and smelting resumed. In retrospect, such labor intensive procedures seem unprofitable under ideal conditions. But conditions were far from ideal which only compounded all efforts. No rains fell the entire month of July. Without moisture there could be no washings of raw ore, a necessary step in the refining phase. That September, Confederate General Sterling Price entered Missouri from Arkansas. His ultimate goal to win Missouri for the Confederate States of America included capture of an important federal arsenal in St. Louis. A portion of his huge force, under the command of General Shelby, found the St. Joe operation directly in their pathway. Workers fled as Rebel soldiers stormed through camp. Miners refused to start rebuilding there for two months. When work finally resumed late in November, cold air pushed down from Canada. The winter months turned unusually brutal. Below freezing temperatures, heavy snows, and frequent ice storms plagued their efforts. By April, thunderstorms erupted and did not subside for weeks. Flooding brought the entire operation to a standstill. To say the company had a disastrous first year would be

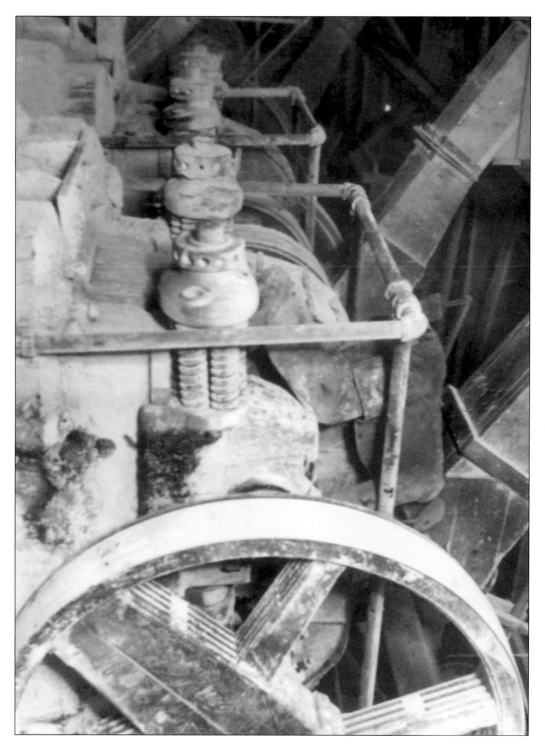

This is a close-up view of Cornish Rollers and wooden shuts inside the wooden mill. (Courtesy of Doe Run Corp.)

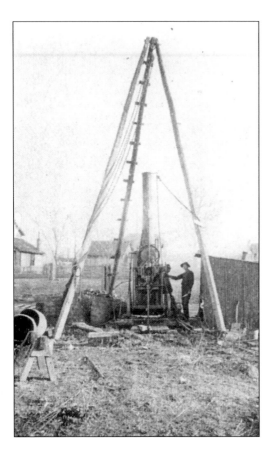

This early steam powered Diamond Drill was first used in Bonne Terre to explore for lead. (Courtesy of Doe Run Corp.)

an understatement.

The mining men, all tough as nails, excessively boisterous, and hardened drinkers, confined themselves in crudely built, single-roomed cabins. It can only be assumed that many lively conversations occurred in these structures about the obvious doom of St. Joe Lead. For a certainty, a group of sage investors with absolutely no experience in mining sat in posh offices watching cigar smoke rise while their company sank. When copies of the first annual report circulated around their conference table, doom and gloom prevailed. Total lead sales of slightly over $17,000 were dwarfed by the total of expenditures which exceeded $34,000.

Those wizards of finance recognized what any fool would know: operating costs cannot exceed income.

They grumbled, studied the figures again, grumbled some more, then wisely decided it best to select a new board of trustees. With the fate of a new company now in their hands, the new board members discussed options. In total agreement, they decided it was best to make a personal visit to the Missouri mining camp and assess what they had, or didn't have.

Days later the group boarded a train in New York. Slow going, at least they enjoyed comfortable seats and beds, plus shelter from outside elements. However, once in St. Louis, the journey turned brutal. Horses pulled buggies over unpaved pathways. Jostled about, nearly thrown out of seats more than once, the group surely thought the trip foolhardy. Once at camp, though, their arduous trek seemed to be well worth all efforts. They were pleased with the quantity and quality of lead reserves known to exist on company lands. By that time, sheets of lead had been discovered no more than eight feet below ground. Blasting those sheets into smaller, more manageable pieces, would increase overall productivity.

Enthusiastic, the board members returned to New York and found ways to liquidate all indebtedness. They reported to other investors that more time and money would be needed but a reasonable profit could someday be reaped. With a feel now for mining, the board sought only the latest in equipment. They purchased and had shipped to Missouri new machinery called cornish rollers. These crushed the lead laden rock into tiny particles. A jigging procedure akin to a sieve then separated waste particles from mineral pieces. Less labor intensive, production steadily increased.

In 1867, St. Joe constructed a frame house in camp, the first of its kind there. Large enough for two small families, this new building served a dual purpose. It showed workers that St. Joe intended to succeed.

This wooden entrance now protects the old mule adit of the original Bonne Terre mine.

Also, they had plans for half of the house to be occupied by a new employee. The board president had hired a gentleman from Northhampton, Massachusetts. He would become an on-sight superintendent. Having worked at a similar concern near his home, the new person possessed experience in all phases of mining and smelting.

That summer, the superintendent and his family arrived at camp. They settled into cramped quarters of the new house, eventually assuming control of the whole building. After observing the operations, the superintendent took charge as expected. With carte blanche authority to make a success, he assessed the operation and made prompt decisions. New water pumps and furnaces were ordered and installed. Next came more crushers and rollers. Finally, more workers got recruited. By the end of his first year of employment the company began turning itself around. Morale increased

so much that workers replaced their crude cabins with frame houses. Marriages brought in women and families evolved. In 1868, the postal service no longer recognized the area as 'The Mines" but as "Bontear," a phonetic spelling of Bonne Terre which would not be corrected until 1876.

The superintendent kept pondering over those enormous sheets of lead which appeared close to the surface. Reasoning that minerals on top meant larger amounts beneath, he tried to think of ways to best determine precisely where employees should start digging. He shared those thoughts with the board president who concurred with his sound logic. Coincidentally, the president soon learned of a new device which would serve good purpose at the mines. However, with the company still deeply in debt he thought it more prudent that he and the treasurer personally finance its purchase and delivery.

In May of 1869, this new equipment arrived at the mines. It was called a diamond drill. The apparatus resembled a tripod, the three legs stretching about 20 feet in height. They supported a hollow pipe fitted with Brazilian diamonds on the cutting, or boring, end. A steam boiler powered the pipe to 300 rotations per minute. The pipe could easily be extended by threading on additional sections as required. Periodically, drilling stopped for core samples to be inspected. That piece of equipment was precisely what St. Joe needed.

As luck had it, drilling only the third site indicated lead at a depth of 120 feet. Satisfied, the superintendent called for a vertical shaft at that exact location. To sink the shaft required nearly six months of non-stop labor. Picks, rods, sledge hammers, and pry bars chipped away at the rock. When 120 feet had been excavated, disappointment enveloped the community. Apparently, the core sample had only penetrated a tiny pocket which contained lead. Undaunted, the superintendent ordered a lateral cut, one parallel to the contour of the surface. Such a cut or tunnel is called a drift. Not long afterwards, a rich vein of lead appeared. Excavation feverishly continued, following the vein as it grew in both width and depth. From that moment forward, all operations took place below ground.

Already, another problem had to be dealt with which had not been of concern during surface processes. Getting rock out of an 8-foot depth was difficult, but not overly so.

From 120 feet was totally different. The solution seemed easy enough: mules. Sturdy carts pulled by strong mules could handle the task. But then another problem. Mules don't walk up vertical walls of rock. Solution? Dig another access starting at

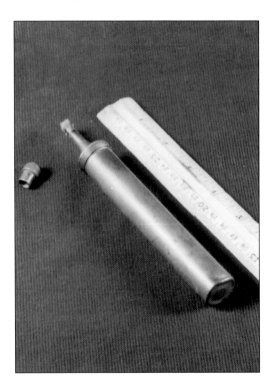

On the left is an early hand-held lantern barely the size of a short candle. The lantern on the right could be held by hand or placed on a ledge or the mine floor.

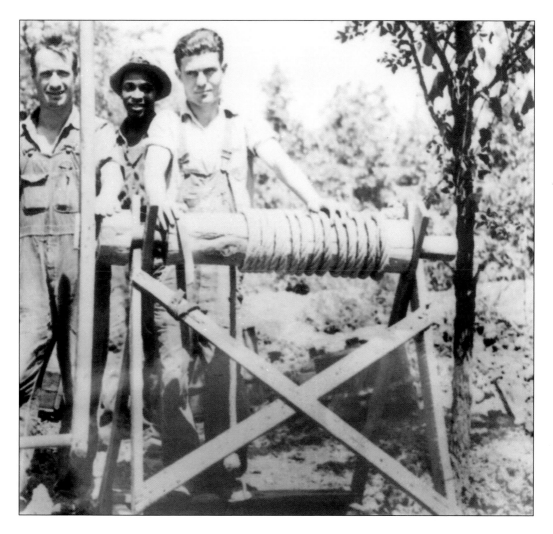

Much trust had to be given to the men who lowered and raised miners. (Courtesy of Doe Run Corp.)

ground level, tapering at an angle both men and mules could accommodate. To maintain a volume of ore adequate to meet rising expenses, more men had to be hired to dig the tunnel.

Beeswax lanterns provided the only light for those working underground. With little more illumination than a candle provides, it is difficult to comprehend how anyone might see beyond a few inches. Of the two types of lanterns first used, a large one could be grasped by a handle or placed on the ground or a ledge. The other, much smaller, had to be held by hand or secured dangerously to a cap. It is assumed the vision of a miner adjusted to such darkness just as it did for the mules.

When the new entrance opened, production of the entire mining operation grew rapidly. The company regularly hired additional crews, reinvested profits in newer, better equipment, and changed smelting procedures. By 1874, St. Joe proudly announced its first ever dividends

to stockholders. It had taken 10 years of hard work, creative financing, and much trust, but the company had survived.

The years 1875 and 1876 continued in prosperity, but the bottom fell out in 1877 and only worsened. By 1878, the price of lead declined to a point even lower than it had been 30 years earlier. All dividends ceased. Trusting that a stronger economy would again return, however, trustees continued buying thousands of acres of land for timber to keep smelters burning and for additional mining exploration. St. Joe and a smaller firm named the Desloge Lead Company pooled funds to construct a narrow gauge railway 13-miles long to haul supplies and pigs of lead to the nearest railhead. Until then, mule teams had sloshed through woods which created deep ruts and became impossible to navigate in rainy conditions. By 1881,

the economy bounced back and dividends resumed. The future surely looked bright.

On Sunday, February 26, 1883, a fire of unknown origin totally destroyed St. Joe's mill. Local, state, and national newspapers headlined the catastrophe as a "Quarter Million Dollar Blaze." While embers smoldered, local management staff gathered to assess the fire damage. Their decision came only hours later. A new mill, entirely of iron, would be built. Furthermore, all new equipment would be installed: crushers, jigs, rollers. In just four months time the new, compact mill commenced operation. Hindsight indicated the fire to have been a blessing in disguise because the new mill functioned with higher efficiency and less costly than the old one. The superintendent supposedly joked that it should have burned years sooner. From then until the company

St. Joe's mill in Bonne Terre is seen here just prior to the fire. (Courtesy of Doe Run Corp.)

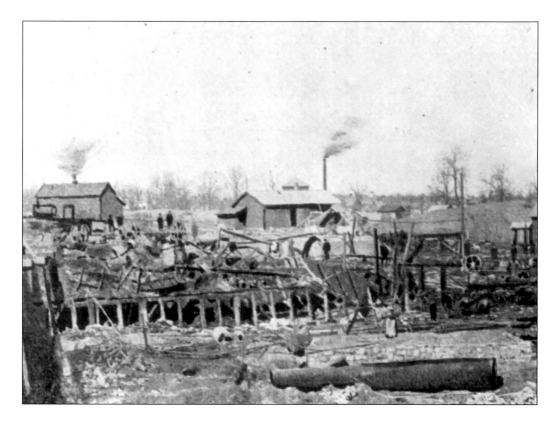

Remains of the mill shortly after the "Quarter Million Dollar Blaze." (Courtesy of Doe Run Corp.)

ended its operations in the Lead Belt in the 1960s, that mill functioned non-stop.

Another mill fire occurred in 1886. That time it was not part of St. Joe's operation but that of the Desloge firm. Instead of rebuilding as St. Joe had done, Desloge sold all interests to St. Joe for $400,000. At about this same period the company thought it economically prudent to construct a new smelter, but not in Bonne Terre. Because lead went north and then shipped out on the Mississippi River, they chose Herculaneum. The narrow-gauge rails were ripped up, replaced by standard track. The end result meant creation of the Mississippi River & Bonne Terre Railway.

Lead pipe, pewter, ammunition, batteries, and other items in strong demand at the time kept St. Joe quite stable. Price fluctuations varied with the national economy, but

stockholders maintained a good outlook and weathered the dips which would periodically occur. Then World War I erupted and lead demand escalated. That outrageous demand would happen two more times: during World War II and the Korean Conflict. A company employee in Bonne Terre obtained data from the federal government regarding the quantity of lead used for bullets in all three wars. By gathering data on how much lead St. Joe sold to ammunition contractors during those years, he estimated between 60 and 70 percent of all rifle ammunition came from the company. That might not be the most desired way to make history but grim times often require us to do the best we can. St. Joe answered the call all three times.

Like most other large operations, the lowest point for St. Joe occurred during the

1930s Great Depression. The company could simply have shut its doors and been financially ahead. No business wants to do that, but St. Joe already had tons of lead stockpiled at Herculaneum. Profits could have been reaped by selling from that inventory and not paying salaries and other overhead costs. Tempting as that must have been, St. Joe felt a moral obligation to assist as many people as it could. Unavoidably, some employees had to be released, however, St. Joe retained what it believed to be a comfortable work force. Work came on a "need to" basis. For employees such as my grandfather, one 8-hour shift seldom more than once a week meant a very small paycheck. Yet, by supplementing those meager checks with large home gardens and careful allotments of cash, most folks kept food on the table and bankers off their doorsteps. This act of good

will by St. Joe cost plenty. Once the decision had been reached to retain skeleton crews, losses continued to mount. Pumps ran 24 hours a day to keep the mines from flooding. The mill functioned non-stop. Accountants had to maintain books. Utility bills remained about the same as when there had been no layoffs. All the while, St. Joe merely stockpiled additional lead along the Mississippi River.

There is no exaggeration in the statement that St. Joe, the world's largest lead company, truly cared for its employees, their families, and the whole community. It always did. From those infant years of incorporation until the lights were turned off underground at Bonne Terre in 1961, St. Joe's first priority centered around people. My step-father served as vice president and division manager of St. Joe. He and I shared lunch one time with a mine inspector. In strict confidence, the inspector

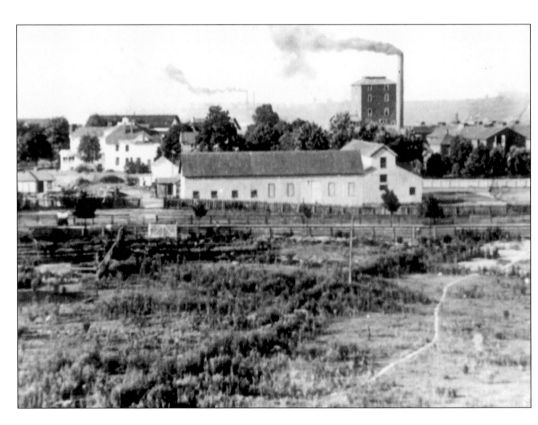

New mill building of iron is seen here in 1892. (Courtesy of Doe Run Corp.)

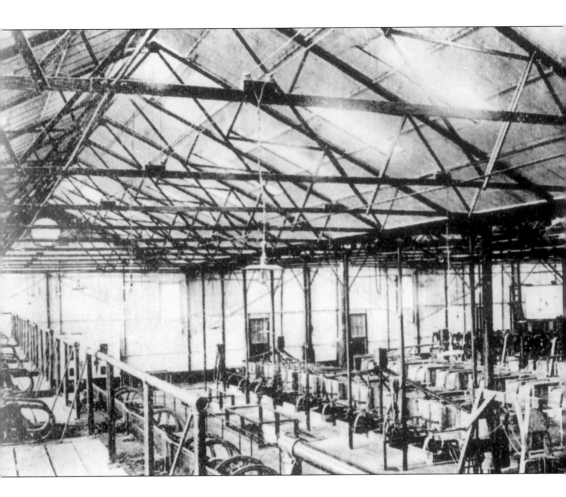

Interior of the new mill, c. 1916. (Courtesy of Doe Run Corp.)

told us that he used St. Joe as a guide when he inspected other companies. That remark nearly duplicates another inspector's report written August 6, 1891, which stated in part: "The St. Joseph Lead Company, Bonne Terre, Missouri, is the most striking example of an ideal corporation I have had the pleasure of coming in contact with."

All businesses, whether large or small, have certain employees with little good to say about their employer. St. Joe was no different. My observations of the nay-sayers indicated they shared many similarities. Most didn't understand what benefits St. Joe provided beyond a weekly paycheck. In fact, many residents didn't know how the company assisted in quiet, unassuming ways. To comprehend those benefits one must first understand what it meant to live in a company town.

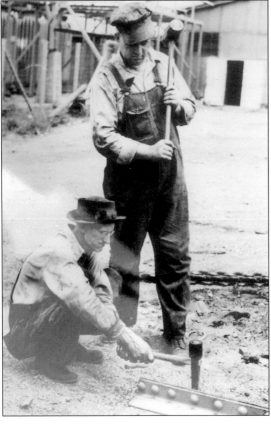

Depression woes. It appears these men have just received new boots, but it is unknown if they were provided by the lead company or the government. (Courtesy of Doe Run Corp.)

Repairing company equipment took steady nerves, good aim, and faith in one's partner. (Courtesy of Doe Run Corp.)

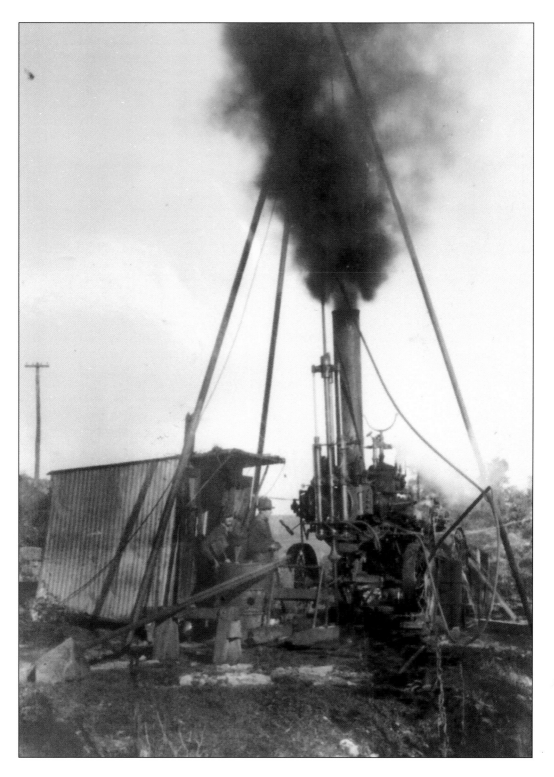

Exploring for new veins of lead continued throughout the 1930s. (Courtesy of Doe Run Corp.)

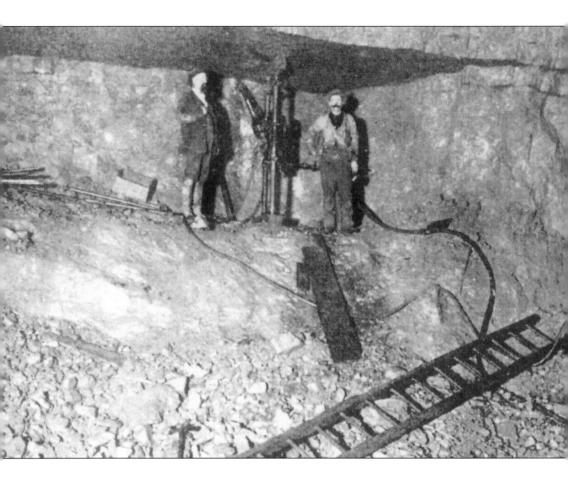

Striking a posed shot for the camera, these men have been smoothing a wall and ceiling of loose rock.

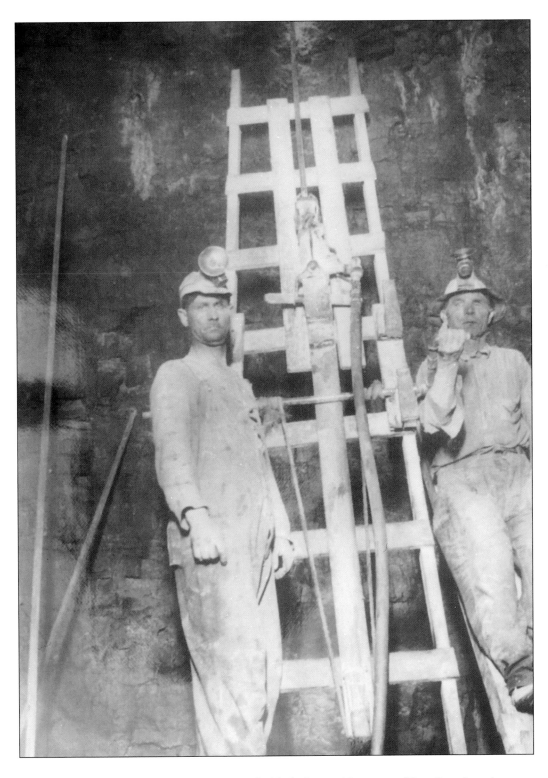

Carbide lamps provided brighter, more reliable lighting. (Courtesy of Doe Run Corp.)

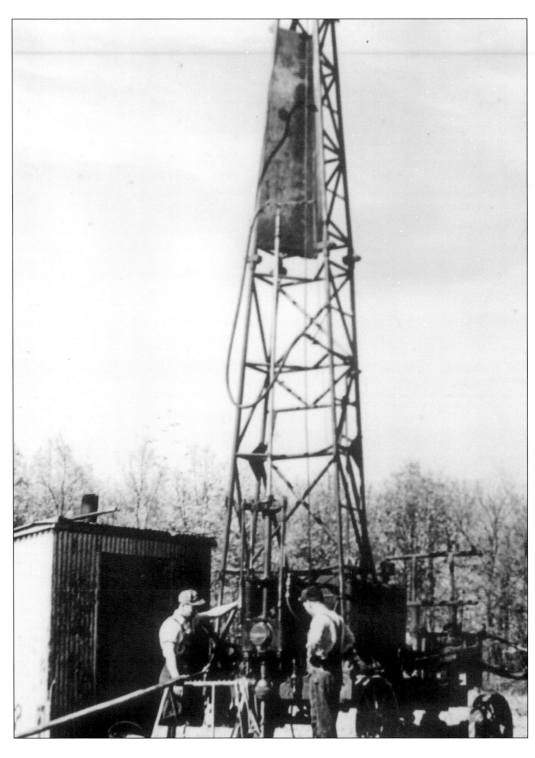

Seen here is the improved Diamond Drill just after World War II. This type of machinery was seen all over Bonne Terre through the 1950s. (Courtesy of Doe Run Corp.)

Chapter 2

THE COMPANY TOWN

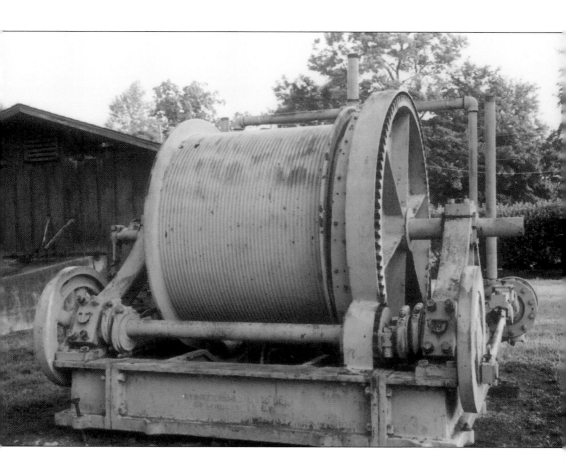

Electric hoist for raising and lowering miners and for bringing minerals to the surface.

Any attempt to separate Bonne Terre from St. Joe would be futile. Just as we humans need lungs and heart both, the town and company needed one another. To merely assert that Bonne Terre was a company town would not serve justice. It was a truly wonderful company town. Negative images we tend to associate with coal mining districts of the Appalachian Mountains simply do not apply here.

St. Joe's role in our national economy and defense proved so vital that electricity reached Bonne Terre long before towns of similar size received the service. For St. Joe, electricity altered its entire operation. Electric motors ran crushers and jigs in a rhythmic tempo with a noticeable decrease in cost. A headframe, a tall metal beam structure with gigantic wheels fixed to the top crossbar, supported steel cables attached to buckets. Electrically operated, one bucket, or cage, lowered and raised miners to and from the mines. The second bucket hoisted chunks of rock to the top. After a brief pause, the bottom opened. Rock tumbled deep into the mine's throat with tremendous force which smashed large boulders into smaller, more manageable pieces. Lighting in offices, mill, other surface buildings, and even underground, became commonplace. The more dangerous fuels for lighting such as gas and kerosene became history.

Bare electric light bulbs soon spread to other businesses, private homes, school, and hospital. The company supplied neighborhood street lamps and then helped maintain them for many years. Local stores began to carry various electrical appliances such as fans and toasters. St. Joe furnished residential water and sewage needs. Local stores began to carry commodes and lavatories. St. Joe built and maintained a golf course and bowling alley. Local stores began to carry sporting accessories. One entity fed the other.

Possibly the single, most expensive contribution St. Joe provided the community got little attention. Not that the company hoped to keep any secrets, but it simply didn't seek publicity. Once a year my father and other accountants with the lead company made an audit of record books for the Bonne Terre Hospital. When ledger accuracy had been confirmed, a full report would be issued to company management. Any deficit incurred by the hospital during the previous 12-month period would immediately disappear. St. Joe cut a check to subsidize the medical facility.

When hospital fee increases could have been easily justified, the company insisted to the contrary. Perhaps the best example to document this goes back to 1946. With the end of World War II, Bonne Terre welcomed home those young men who had given a good portion of their best years in defense of our country. Like most towns in America, not all returned alive. For those who survived, heroes all, the town embraced them. Like my father, many men resumed positions they held before the war had started. Some found work with the railroad or at local retailers. Still others decided to start their own businesses. But regardless what they chose as careers, all seemed to start families. By late summer of 1946, the first wave of "baby boomers" arrived. It signaled the beginning of a population explosion which would continue for years. During this surge of maternity business the hospital could have easily increased room and board fees, medicine costs, and staff charges. The hospital board received assurance from St. Joe that the company would offset any losses.

My entry into this world came one day before Halloween of that year. I still marvel at the hospital statement over a half-century later. Typically, mother and infant remained hospitalized for 10 days. The bill for me and my mother reads:

10 days for mother @ 6.50	$65.00
10 days for baby @ 1.25	12.50
Delivery Service	10.00
Circumcision	2.50
Special medicine	.50
Total	$90.50

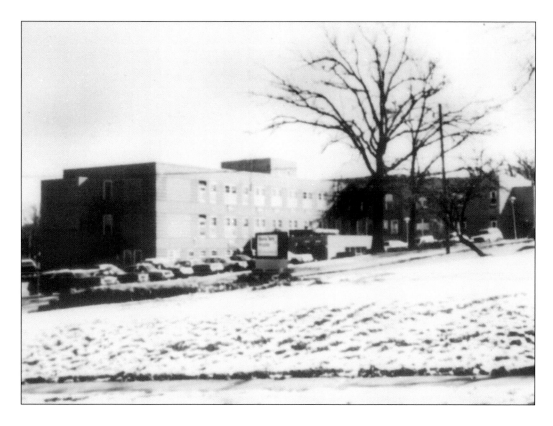

Bonne Terre Hospital which helped usher in the Baby Boomer generation. (Courtesy of the Wilke Collection.)

Bonne Terre Hospital serviced towns in a 45-mile radius or more. Nearly every child born in the 1940s and 1950s, whether their parents lived in Fredericktown to the south or DeSoto to the north, Ste. Genevieve to the east or Potosi to the west, or all the Lead Belt communities such as Flat River, Farmington, Desloge, Elvins, Esther, and Rivermines, will show Bonne Terre Hospital as their place of birth. Thus, St. Joe Lead Company subsidized delivery costs for everyone, not just its own employee's families.

My earliest memories do not allow me to remember the first residence I lived in. My parents married the day before Pearl Harbor and had rented a detached building at an apartment house on Division Street. Cramped quarters even for two people, my father soon left for the war. My mother then had it to herself until my dad returned in 1945. Somehow, the three of us lived there until late in 1949. Becoming true Americans by going in debt, my parents bought a house two blocks up the street. Not much larger than the apartments detached unit, at least the house had two bedrooms.

Bonne Terre's police chief lived across the street, and the two of us soon became close friends. I remember him looking much like Rod Steiger in the movie *In The Heat Of The Night.* He carried a middle-aged plump belly with a round red face to match. Remembering back to that time, I honestly believe that particular position to be the very best in town. I can imagine only one question needed to be asked when interviewing: "Are you capable of sitting behind the steering wheel at the city square for eight hours a

This house on Division Street where the author and his family moved to in 1949. Except for the front porch addition, nothing has changed.

day?" A positive reply got the job. I know that didn't happen and is extreme, yet it makes my point. The most exciting event our police chief performed with regularity occurred when leading funeral processions from a church or funeral home to one of the cemeteries. He then had a rare opportunity to test the red light on top of his car. More exciting but less often he could sound the siren to warn motorists at intersections to sit still and pay their last respects. He spent the remainder of his time parked beside a drug store on the town square. Although discouraged from doing so, sleeping on duty seemed acceptable but only when wearing dark sunglasses. The upshot is that gasoline bills and vehicle upkeep remained minimal.

In all fairness, both he and his later replacement were highly qualified, well-liked men. We simply had little else for them to do which isn't a bad thing at all. When something did occur it would typically be of a petty nature. Had a serious situation presented itself, either one would have responded quickly, shown concern, and worked hard to resolve the matter in a professional manner.

One thing which always peaked my curiosity about Bonne Terre was the street design. What few arteries actually run parallel to each other must be mistakes. Most streets run at odd angles. A widespread belief existed that originally a design had been formulated to resemble a wagonwheel. A triangular wedge in front of St. Joe's

central office was to be a hub. Wide avenues like spokes were to be long and straight, spreading further apart the longer they got from the hub. Smaller, neighborhood-like streets were to connect them by running in opposite directions. If true, the plan never fully materialized. Only two such arteries exist. One is named Church Street but can only boast of having one house of worship facing it. The second is known as Main Street but never did it serve as anything more than a residential section.

Whatever happened to the wagonwheel plan if one truly existed, and I believe it did, got tossed aside. It's highly probable that a new plan emerged from one of Bonne Terre's saloons from the early days. Someone might have forced one too many alcoholic drinks down a mule's throat, kicked the beast, and followed after it. Wherever that animal staggered got marked to become a street. There are two intersections of five converging streets. Those are always fun to navigate regardless of age and driving experience. To complicate matters, both are the busiest intersections in town, with one of them even situated at the school. At least five other sites have two streets merging which form "Y"s. They always provide great challenges for those first learning motoring skills.

As confusing as this design or lack of design sounds, it did afford some of us great pleasure when offering directions to lost souls. For example, while playing tennis at the school courts one day, I heard a car pull into the parking area behind me. I walked

This intersection by the school once had five streets converging. Since then an island has been added to make it a six-way intersection.

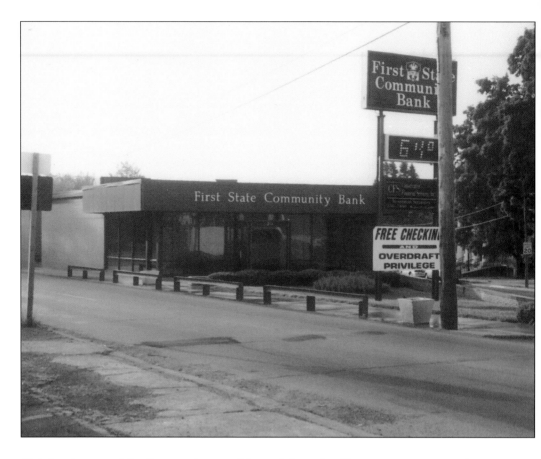

This bank was originally a savings and loan. It is wedged between two converging streets to form a "Y."

over and politely asked what assistance I might provide. The driver wanted to know how he might find our hospital. With comforting assurance, I cleared my throat and said, "Pretty easy." I pointed toward the elementary building which was in clear sight and proceeded with my directions. "Go to the stop sign up there. Turn left and go to the next stop sign. Turn right, then zig left of the Masonic Temple. Take that street until you see the hospital. It's across from a scummy pond." One had to know when to zig, zag, or veer when offering directions. And, note that not one street name got mentioned. There is a logical explanation for that. Most of us didn't know all the street names. We had no need for such useless information.

We knew where everything and everybody could be found. How embarrassing it would have been for us to admit to a stranger that we didn't know street names in such a small town. On another occasion I found myself walking down our business section being hailed by a car that blocked traffic behind it. The driver rolled down his window and asked where a particular street might be found. Until then I didn't know Bonne Terre had a street by that name. Without showing my ignorance I approached the problem in a different manner. "Who is it you're wanting to visit?" I asked, hoping I didn't sound too nosy. "The so-and-so's," he told me. Not only did I offer directions to so-and-so's house, but I described the structure

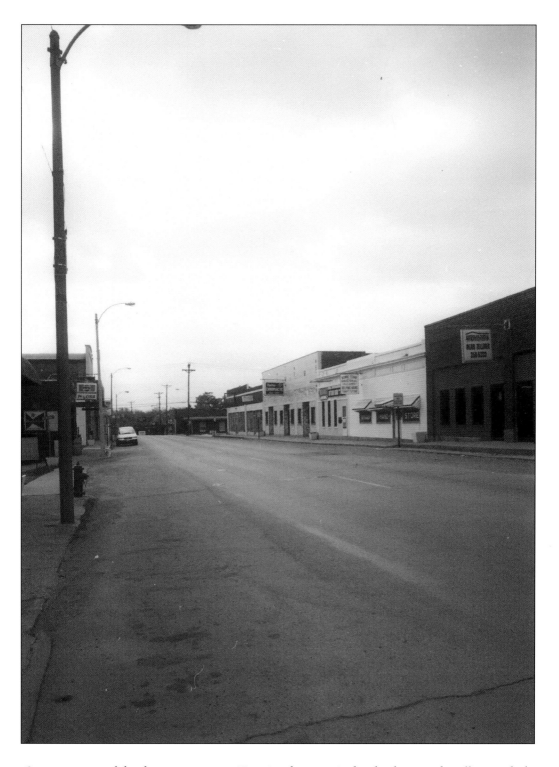

Current scene of the downtown area. Here is where an individual stopped traffic to ask directions to "so-and-so's house."

in detail, including shrubs which lined their walk.

I have not had an opportunity to view Bonne Terre from the air. I once thought it would be interesting because I imagined it to favor a great maze. Today I'm not sure. I might spot a car driving around still searching a place I offered directions to many years ago.

Bonne Terre's population hovered around the 3,000 figure my 20 years as a resident. Supposedly, 1907 figures showed 7,000 people living in town. Most of the extra population can best be explained as migrant workers. At that point in history there were numerous expansion projects nearing completion. The railroad had constructed additional lines, St. Joe nearly doubled its employment force, and new buildings were going up for the company and as individual homes.

Most houses constructed during the turn of the century included spacious front porches. I vividly recall how people gathered on those special places which typically included swings, gliders, and rocking chairs. World problems got peacefully resolved when neighbors stopped by to visit. House additions were worked out as well, usually with a promise that others would lend a hand. Naturally, any late scandal would be dealt with at much length and analyzed until nothing else remained to be said. Lemonade, iced tea, and ice cream floats got downed in large quantities.

Socializing also took place when shopping in local stores. One always passed the time with a clerk, cashier, or other shoppers.

St. Joe and town residents built spacious houses such as this one between 1880 and 1920. Large porches and equally large shade trees once invited neighbors to stop by and visit.

Communication simply was an expectation, a sign of caring. As peculiar as it sounds, we even socialized at the city dump. Not until my late teens did Bonne Terre offer any sanitation collection at the curbside. Until then, trash had to be taken to the dump by the homeowner.

Garbage got packed tightly in galvanized trash cans until not one speck of dust could possibly fit in. That served as a signal that time had come to make the trip. Cans and leaky paper sacks got lugged to the vehicle. All too quickly the trunk or rear end of a station wagon reeked of garbage. This brought about two immediate reactions. First, every window had to be lowered. Secondly, drive with all haste by the shortest possible route to the dump. When there, an order for disposal had to be strictly followed.

Bags were tossed out first, cans came out next. Doors and windows remained open to fumigate the interior. Meanwhile, should someone else be performing the same chore, and they usually were, conversations struck up just as though they were visiting on a neighbor's porch. Even should no one else be dumping their trash, the overseer would gladly stop his noisy bulldozer to pass the time of day until the vehicle had aired out. Kids never had a problem amusing themselves while the adults talked. Looking at other folks discards or hurling rocks at mice and rats offered a great pastime. Yes, a trip to the city dump became an exciting occasion for the entire family.

Being situated on a rail line, Bonne Terre had four visitors twice a year, regular as a good running watch. Hoboes, real ones that

This liquor and candy shop entertained adults and young children alike. It is one of the few buildings in the business section that has not changed.

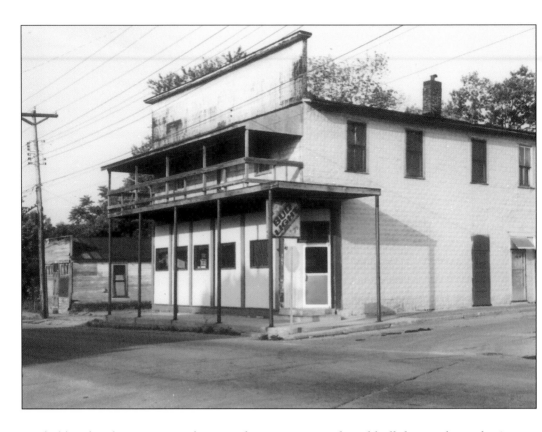

Probably a hotel at one time, this served as a tavern and pool hall during the author's time in Bonne Terre. The pressed tin siding has been there over 60 years.

hopped freight trains from town to town, stopped in for a few days each spring and fall. Both of my grandmother's houses were known as hospitable places to obtain food. These riders of the rails would rap softly on the back door until one of my grandmothers appeared. Politely, each would take his turn greeting her by name before daring to ask for nourishments. "Fine weather we're having," one might say, and then a few moments passed in conversation about that topic. Or, "How's your husband doing?" one might inquire. Seldom would either grandmother wait for them to ask about food. Invited to take a seat around the back porch, the hoboes waited while my grandmothers prepared something. In 10 minutes or so their refreshments arrived. Sandwiches, a bag of chips if any could be found, and tea,

coffee, or soda were the common fares. I often times sat among them, listening to stories but seldom partaking in those colorful conversations. Meanwhile, my grandmother would retreat to the kitchen to fill sacks with canned goods and perhaps some instant coffee for the gentlemen to take on their journey. Appreciative, all four doffed their hats, thanked their hostess, turned and left. Being too young at the time to appreciate the mysterious callers, I have often wished there could be a way to relive those moments so I could ask questions and learn more of their experiences.

Two other fellows made periodic stops for handouts. These two lived in a cave outside of town. They were bums. The pair received less enthusiastic greetings compared to the hoboes for obvious reasons. They always

seemed filthy, their boot or shoe soles flapped with every step they made, and their coats and pants were tattered and smelled worse than garbage in the trunk of an enclosed car. Only one of my grandmothers took pity on them. Unlike when the hoboes called, she had the pair wait at the backdoor while she quickly gathered a few canned goods and perhaps a loaf of bread. Keeping her distance, she passed the sack hurriedly. They thanked her and made their departure with equal haste.

My other grandmother refused to answer the door when the bums appeared. Why they continued calling there I cannot explain. Whether she knew it or not, my grandfather is the one who took care of them in his own manner. His favorite rabbit hunting area happened to be where their cave was

situated. Not every hunting trip but often enough he secretly grabbed cans of supplies along with a bottle of his homemade wine and put them in his hunting jacket. On two occasions I happened to be with him when he performed his act of kindness, although he would never have wanted anyone to know about it. Near the cave we would stop walking while he called their names and then identified himself. A pair of friendly hellos in return meant for us to enter. We never stayed long, just unloaded the supplies, mentioned the weather, then took our leave. Their fate remains a mystery. Neither of them were seen after the mid-1950s. My grandfather once told me he suspected they probably died and had been eaten by wild animals. I don't know if he meant that or not. He didn't crack a smile as he said it, but then, he didn't smile a great

Placed on top of a hill as one enters town, this tavern and grocery was one of the town's busiest establishments. (Courtesy of the Wilke Collection.)

deal until he got much older.

Having a railroad in town from the late 19th century benefited all of St. Francois County, not just St. Joe Lead. Transportation to and from St. Louis in a single day was a luxury which otherwise would have been impossible. Passenger service during the great fair of 1904 allowed residents of the county to make repeat trips without the need to spend funds for hotel lodging. Unfortunately, passenger service ceased in the 1940s. Automobiles and concrete highways made travel accessible to more and more people. However, freight service continued because the company used it to transport machinery and minerals.

My grandfather who fed the bums worked as a blacksmith for the railroad. He did me a great favor which I couldn't fully appreciate

until many years later. When I was about eight years old, he walked me to the depot one Saturday morning. Nothing was mentioned as to the purpose, but I didn't care. I always enjoyed snooping around the old depot. Baggage and mail carts with iron wheels were outside the station. Those worn objects showed scars from decades of use. Inside, the lobby area displayed poster-sized prints of trains. The ticket counter with metal bars stirred images in my young mind as to what it must have been like in days when passenger service still existed. At the rear of the station sat a man tapping out a musical rhythm on a telegraph key. He worked for Western Union. I would stand in a doorway and observe him operate that device with my mouth wide open in amazement. Not long before this

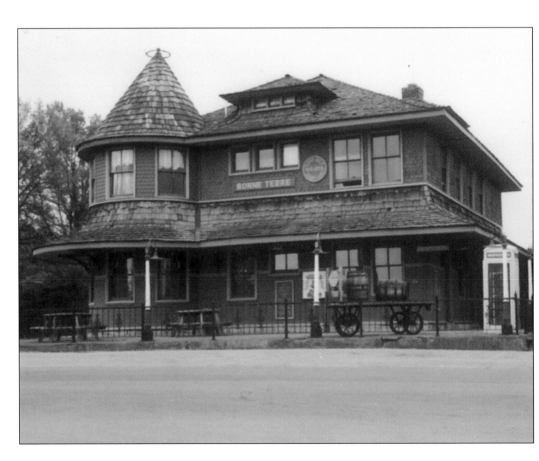

Pictured here is the Mississippi River and Bonne Terre Railway depot.

particular trip I had been present when Mrs. Casey Jones arrived to display the whistle from the engine Casey engineered the night he met his death. To me, that depot seemed like a magical kingdom.

When my grandfather and I arrived on that Saturday, however, he did not let me wander around. Instead, a large black steam engine idled on a siding and that is where he led me. Inside the cab stood a co-worker of my grandfather. The man looked as big as Charles Atlas. He called out a hearty greeting and waved to me with a gloved hand. I waved back quite shyly, even though I knew him well. He then stooped low to the ladder rungs while my grandfather started to hoist me up. Terrified, having no idea what this meant, I did what any youngster would do. I screamed, cried, and kicked with mighty force. My grandfather apologized to the man and said perhaps we might try again the next day.

Only on our walk back to my grandfather's house did I learn what should have been told to me in the first place. That steam engine, the last one in Bonne Terre, would be replaced by a diesel locomotive the following week. He had arranged for me to be the last rider on the retiring steamer.

Sunday morning found me still nervous but better prepared. Yet, our walk in near silence only allowed my mind to think of horrible things that could happen. When we arrived at the siding there came a repeat performance like the previous day. From inside the cab came a loud hello followed by a wave of a gloved hand. I soon felt two hands grab my waist and then I got swept off my feet and into the cramped cab. The engineer checked numerous gauges and dials, turned a valve, then tugged at an overhead rope. A high-pitched whistle broke the morning air. A sudden jerk about tossed me to the floor. Gradually, the train chugged out of the rail-yard. We went up behind an iron foundry, atop a ridge beside the pond, and into thick woods. Slowly rolling along, the engineer held me out a paneless window and encouraged me to pull the rope which made the whistle blow. Less frightened the further we traveled, the train pulled into Leadwood sooner than I expected. The engine needed several large scoops of coal and then we retraced our path back to Bonne Terre. Happy to have made the last ride, I admit my thrill when both feet stood on solid ground again.

The next week our family drove to the station to see what the replacement looked like. I thought it resembled a bully. Shiny blue, squatty to the ground, the contraption failed to impress me. To this day I can't get excited over trains like some people do. However, I recognize that even the diesel is experiencing its own slow death. Fewer trains criss-cross this nation of ours these days. The 18-wheeler is making the iron horse obsolete.

St. Joe opened a company store in 1865 for its employees' convenience. It expanded operations in later years to include several farms which provided fresh meat, milk, and eggs. They called this entity the Bonne Terre Farming and Cattle Company. As the town grew and independent establishments opened for business, St. Joe did what many company towns could only wish would happen—it welcomed the competition and even urged employees to shop at the new retailers. St. Joe wanted to focus its attention on mining, not farming and retailing which never brought much profit anyhow. As soon as possible, management closed the company store and sold the farms. That made Bonne Terre even more self-sufficient.

For a town of 3,000 residents, our business district catered to most needs quite nicely. Numerous supermarkets served the town and surrounding rural area but never seemed to interfere with neighborhood stores we referred to as corner markets. We had several clothing stores, furniture stores, hardware shops, two drug stores, a hobby shop, liquor store, fabric shop, shoe repair, a bank, savings and loan, Western Auto, my

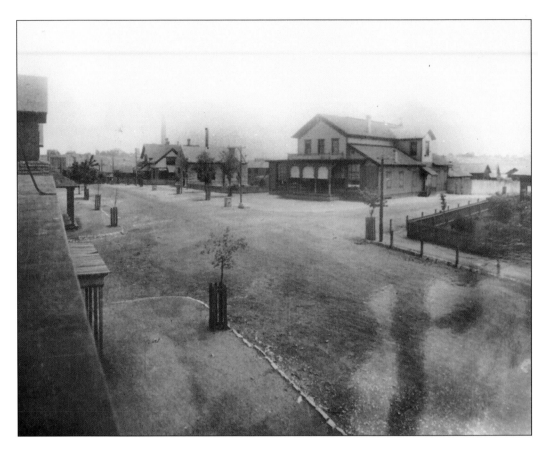

The Company Store building in the upper center is seen here as it appeared c. 1880. Note bandstand at right. Numerous trees are protected by fence and several still are alive today. (Courtesy of Doe Run Corp.)

uncle's jewelry shop, various full-service gas stations, a bakery, five-and-dime, and the usual array of taverns. Smaller businesses operated outside the main district as insurance sales, real estate offices, beauty and barber shops, and funeral homes.

How residents referred to the main business district seems interesting. Some called it "downtown" while others said "uptown." I recall how one time I tried to determine which to be most appropriate. My final analysis indicated that most people who lived north of the town square said "uptown." I discovered a logical explanation for that. The northern part of town sat lower in elevation compared to the business section. Getting there meant going uphill, hence uptown. But there seemed to be no logic for those on the southern half of town. They used "downtown" yet the elevations were nearly alike. To rural folks, "town" was good enough.

On Saturday mornings, all country roads led to "town." The routine had been part of our local Americana for over a century and would continue for many years after I left home. Farm families kept an ongoing list of material needs throughout the week. Saturday, they came to fill those needs. Parking became a real problem after about 10 a.m. on that one day of the week. There would be medical and dental appointments,

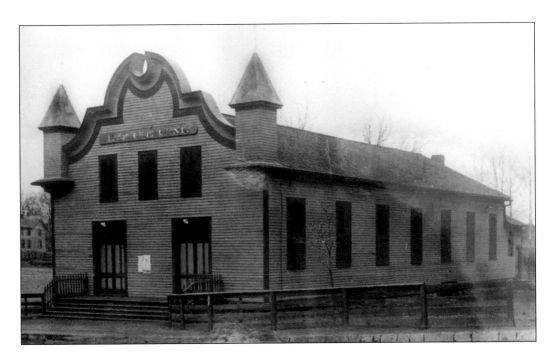

The Old Lyceum building is pictured here, c. 1880. (Courtesy of the Wilke Collection.)

The Lyceum building was remodeled and became the Bonne Terre Farming & Cattle Company. (Courtesy of Doe Run Corp.)

banking, lumber and livestock feed to buy, not to mention the major reason for being in town, grocery shopping. Any pleasure buying or window browsing had to be accomplished before groceries were purchased. Once the food had been loaded into trucks or cars, the family had to rush back to the farm to keep cold items from spoiling.

With only one exception, Sunday's atmosphere in the business district turned about-face compared to Saturday. The exception happened to be the local bakery. Doors opened around six in the morning. Regardless of weather, a line of customers often snaked its way out the door and onto the sidewalk. Fresh baked bread, cakes, pies, and various pastries were regular Sunday items for many families. Traffic then waned to a trickle by mid-morning and seemed to totally evaporate around 11 a.m. After locking the door and cleaning cases, ovens, pans, and the floor, the baker and his family could return home—but not for long. Most Sunday afternoons became a frantic scene with deliveries. Wedding cakes, anniversaries, and family reunions turned those hours into a catering service.

Few residents understood or had any insight into the life of a baker. Open Tuesday through Sunday, operating that business required an endurance level most would have found impossible to maintain. On weekdays, the typical hour to begin mixing and baking started not later than 3 a.m. Saturday's started an hour earlier. Sunday morning work began at not later than 1 a.m. Many bakeries today use pre-mixed blends, all items already measured, stirred, and packaged. Add water and put in the oven. Our baker made everything from scratch. Nothing I find today remotely compares to the pastries I enjoyed back then. Besides operating his business, our baker served on the school board, participated in the Chamber of Commerce, played on both a golf and bowling league, not to mention being a husband and father. When ill, he did not have the pleasure of calling a substitute.

He pried himself out of bed, dressed, then went to work as usual. How he maintained his cheery personality is astonishing.

When the bakery locked-up on Sunday mornings, the entire retail district looked like a ghost town. By that time, church lots were anything but ghost-like. Small as the town might have been it certainly had representation from many of the mainline denominations. We had Catholic, Church of Christ, Methodist, Baptist, Congregational, Christian, Assembly of God, Episcopal, Lutheran, and African Methodist Episcopal to name most. Each played an active role in our lives. And, in their own right, those religious institutions became a great part of the cement which held our town together. Kids of one church might attend two or three Vacation Bible School sessions sponsored by other churches. In a spirit of ecumenical unity, community-wide Easter Sunday Sunrise worship was held in a different church every year. A choir of mixed denominations provided special music. Accustomed to rising early anyhow, mining families filled most celebrations to standing-room-only capacity. Midnight services on Christmas Eve also united various denominations. Only on those two occasions would members of our African-American population be in attendance.

Bonne Terre served as a melting pot for a wide variety of nationalities. Yet, there were African-American people among us who clustered themselves to a particular section of town. For many years they supported their own private school. The AME Church tended to be their only house of worship. Unofficially, some people referred to the area as 'Coontown.'

What might seem obvious today did not get much attention in those years. Time, education, and experience have a way of provoking questions today which were not raised during my youth. Why did the African Americans congregate in a compact section of town? Why did they not worship in the other churches on a regular basis?

I am confident that societal pressure and expectations from previous decades had much to do with it. When their school closed and the few remaining children entered the public system, the kids seemed to be accepted as equals, and I hope that is true. However, I do know for a fact that pay rates differed for those of color employed at both the lead company and the railroad. One or two women performed laundry services for white families, my own included I'm sorry to admit. Did they do this because they enjoyed it?

My family did not tell racial jokes as so many other families did. Both grandfathers worked 40 hours a week alongside men of color and had only kind, dignified remarks about their co-workers. Through my grandfathers I became acquainted with every African-American resident of town at a very tender age. Their southern heritage still dominated both their speech and mannerisms. Polite, caring, and always interesting, I enjoyed every opportunity I had to be in their presence. Not once do I recall hearing any complaints from them about their jobs, wages, or housing.

When Rosa Parks refused to sit in the back of a city bus in Montgomery, Alabama, December 1, 1955, civil rights became a household phrase and a national movement. The majority of us in Bonne Terre saw it as a problem isolated to the deep South. Ignorant of our own ways, we failed to look in a mirror to see what we had created and continued to inflict on those with whom we lived. I can't help but imagine that the people of color in my hometown

The First Congregational Church was completed in 1911. Brick pillars connected with wrought iron fencing surrounded the premises.

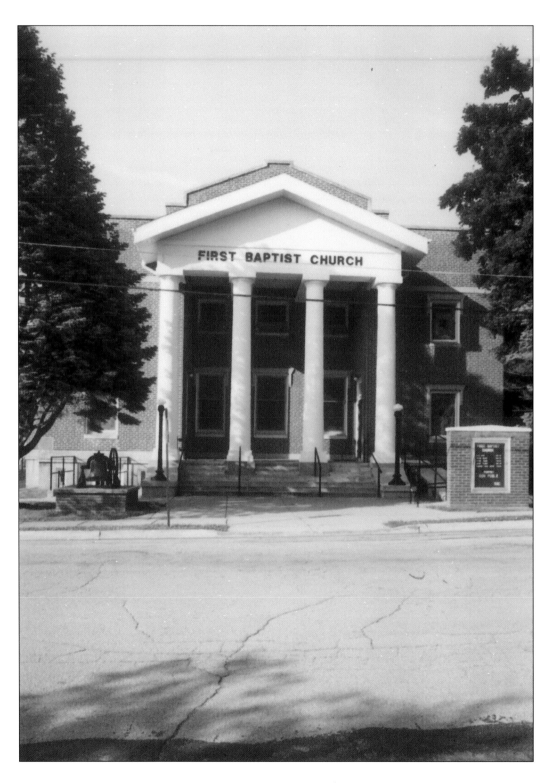

The First Baptist Church is pictured here.

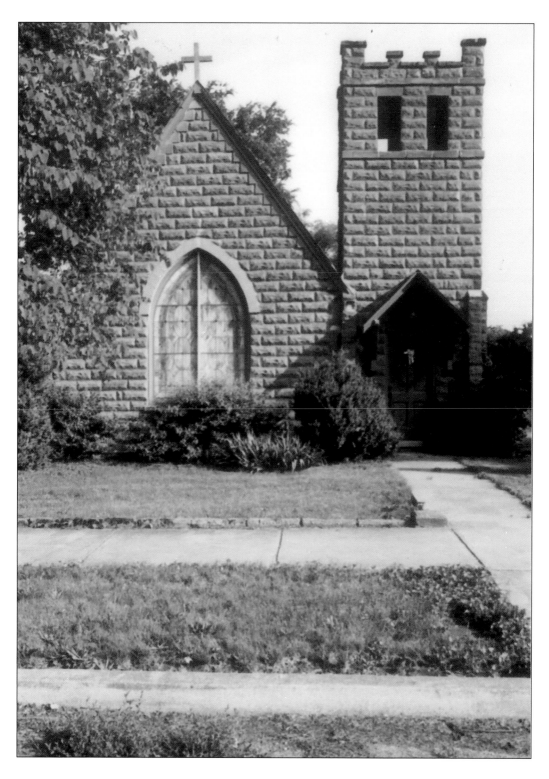

St. Peter's Episcopal Church resembles a European style.

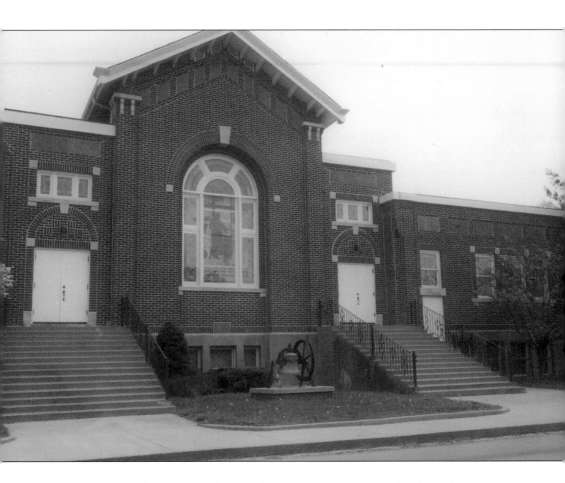

Centenary United Methodist Church of 1918 is seen here. This is where the author attended worship services.

<small>Opposite:</small> *St. Joseph Roman Catholic Church. The basement hosted worship services from 1906 until 1916, when the superstructure was added.*

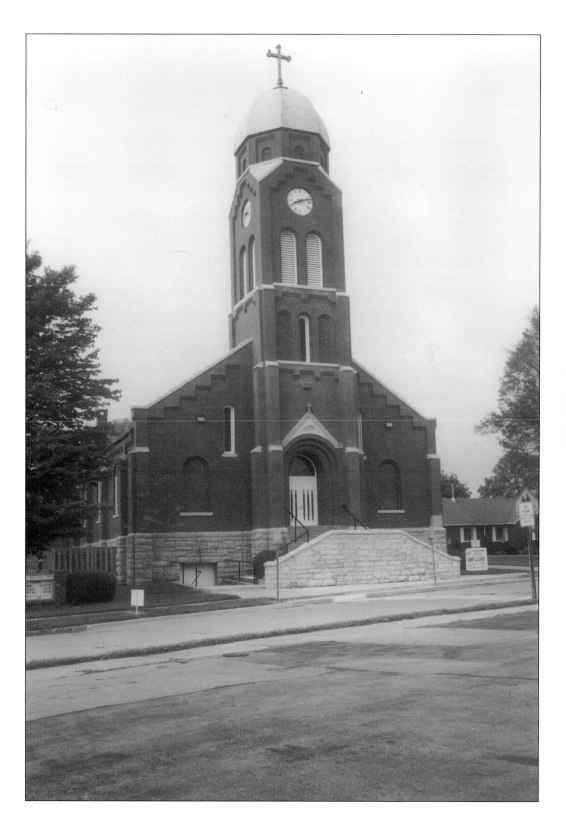

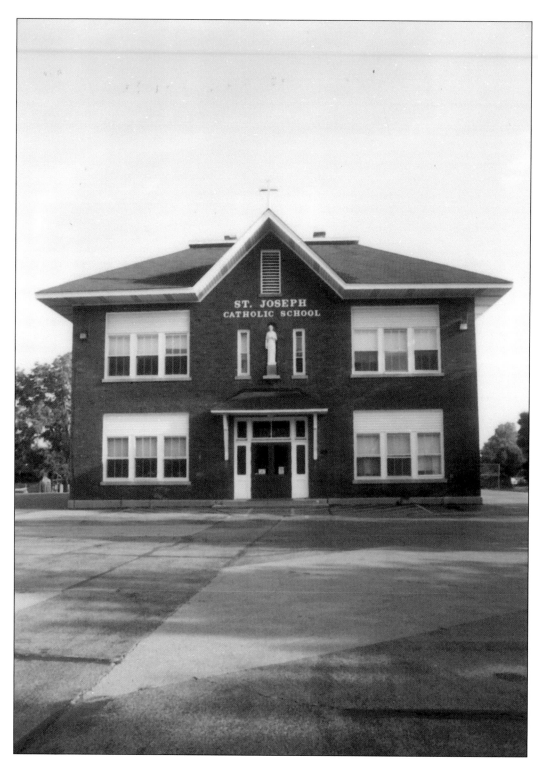

St. Joseph's Catholic School still educates young people through the elementary grades.

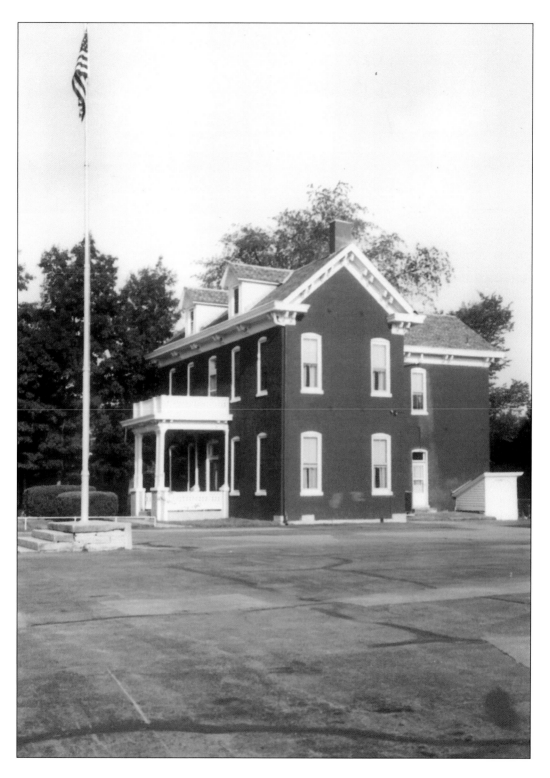

The St. Joseph's rectory is beautifully maintained.

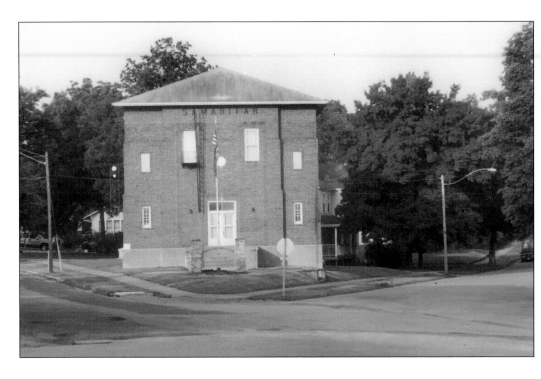

The Masonic Temple is where Church and Main Streets merge.

had a fireball of resentment deep in their stomachs. We simply ignored the truths and we were terribly wrong. I believe this might have been the ugliest wart Bonne Terre ever wore. I only hope that enough of us can now see through the cosmetic cover-up and never permit it to happen again.

Of a milder sense, another form of discrimination also took place. Today we would call it sexism, but that word would have never been used in the 1950s. A summer playground program, supervised by a school coach, gave us boys something to do with our weekdays. We gathered at the ball diamond in the mornings and played all day with only a brief lunch break. The program proved popular and it helped boys develop skills needed in junior and senior high sports. No such program existed for girls.

Because Bonne Terre had a hospital, and with the lead company needing medical staff on hand for rare emergencies, the town supported several physicians and two dentists. Each one accepted appointments but that didn't really matter. When we needed to see one we merely walked in, sat down, then waited our turn. Even more impressive is that most of our medical practitioners made house calls. My mother suffered weakened lungs due to a childhood ailment. Common colds or a flu virus posed serious potential health problems to her. Often times a doctor would be summoned at 2 or 3 a.m. by my father. Twenty minutes later the doctor would arrive, accept a fresh cup of coffee, carry it to the bedroom, and pull a chair alongside the bed. Like a family member, he would converse about everyday events while checking pulse, temperature, and throat. Never hurried, the exam would be completed with a description of findings in terms even I could understand. A small quantity of medicine might be left along with a prescription. He would then insist that he needed to leave after just one more cup

of coffee.

Our dentists performed their treatments in a similar, non-hurried fashion. Waiting rooms might be full, but walk-ins did not feel like intruders. These men spent whatever time it required to attend their clients, making the individual feel as though no one else waited in the next room. And, neither became sensitive about payment for services. We paid when possible, as much as possible, until the debt zeroed out.

All those highly skilled professionals served others because they cared, not for financial riches. Their homes differed little from anyone else's. Their automobiles were no more special than other residents. We called them by their first names and they knew their patients by first name without aid from a medical chart or an assistant.

Every town has an individual known as a "character." Bonne Terre blessed itself with three at one time. Respected in separate ways, each was well-known to the entire town. And, although mentally challenged, each possessed a unique area of the brain which functioned in a manner totally opposite the rest of their behavior.

The first man carried pockets of keys mixed with coins and greenbacks. His primary interest in life was restricted to asking for nickels to purchase a cup of coffee. Gracious when someone complied and equally gracious if denied, he held a trick in reserve. Should the answer happen to be that all one had was a dollar, or a five, or even a 10, he would pull a little surprise. "I got change," he would announce while digging deep into a pocket. In seconds, a handful of keys, coins, and bills would emerge. Counting out change, he would

At one time a physician used this as his office. (Courtesy of the Wilke Collection.)

come up with 95¢ and then dollar bills if necessary, whatever it required so the contributor had donated only 5¢.

Number two leaned toward the comic side. He owned a unique vocabulary of meaningless but hilarious phrases. One day he might call someone "fluter," the next day he might call them "burfturder." He worked most times for one of the drug stores. His major responsibilities included keeping a cigarette rack filled to capacity and emptying trash cans into a large container outside. This fellow formulated a plan of never having to buy his own smokes, although he went through two or more packs per day. From a carton of 10 packs, he would remove nine and place them in the dispenser. Carefully, the carton got a nice twist to make it appear empty before it got tossed in a trash can. He then went about his other duties. When time came to empty trash, he sorted through those cartons with twisted ends. He would remove the single pack and stuff it in a pocket. This made his nicotine habit cost free.

Our third character was quite reserved and didn't wander around town like the other two. He remained close to a business operated by his family. However, in summer months he walked to the golf course two times a week looking for lost golf balls. When finished, he would come to the clubhouse where I worked to see if anyone might be interested in buying the balls for pocket change. I bought him a soda and candy bar one time and he never forgot it. He called me his buddy after that. Later, when someone lingered at the clubhouse, this fellow might stroll in all hot and sweaty and say to them, "He's my buddy," and point toward me. Continuing, he added, "He buys me candy and soda. He's my buddy." The essence of his hint implied that should they also buy him a cola and candy bar, they too would be his friend. It worked. He seldom had to buy his own snacks.

Personalities define individuals. The three I have described had some sort of lasting impression on everyone in Bonne Terre. The same holds true about how we impact others today. Each of us is different. St. Joe employed a wide variety of men and women over their long period of operation. Unskilled laborers such as shop workers, miners, and night watchmen, seldom had much education. Bookkeepers, accountants, and secretaries tended to have at least obtained a high school diploma. Most often they had acquired special skills taught by great teachers. Upper level workers in the computer area and engineering had a minimum of a Bachelor degree if not their Master's. Yet, all these folks worked together, side-by-side, day in, day out, for years on end. To accomplish such a feat meant putting aside educational arrogance, large egos, and salary variations. Instead, respect for each others learned abilities brought a balance of harmony rarely seen in the modern workforce.

Outside the workplace, that unity of acceptance not only prevailed but even escalated. The entire community obeyed a higher order of mutual respect for others. With much frequency, I recall occasions when events in our school auditorium brought hundreds of people together. To see a family from St. Joe's upper management being flanked by families of toughened miners warmed the heart. Even more impressive is how they recognized each other not as co-workers, but as friends.

Chapter 3

ONLY IN
BONNE TERRE

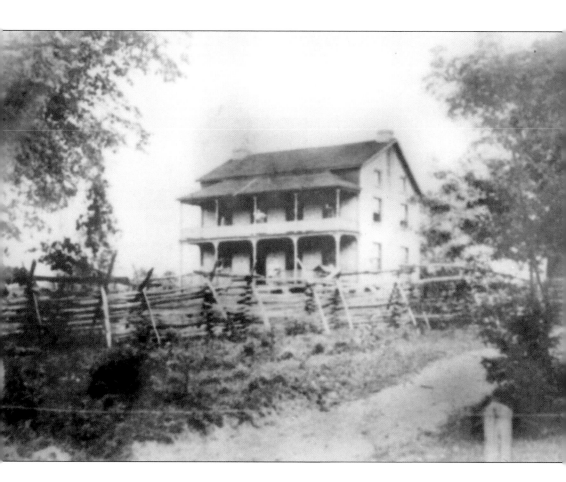

Hildebrand house is seen here as it appeared before being burned. (Courtesy of the Wilke Collection.)

During the 19th century there lived a man named Sam Hildebrand. His home and farm lands were located just outside what later became Bonne Terre. During the Civil War he is alleged to have gained the dubious reputation of taking from the "haves" and providing to the "have-nots." Animals, jewelry, and money frequently disappeared from the homes of wealth. Later, those same items might appear in abodes of those who struggled to eke out an existence. So infamous did he become that a bounty for his arrest, or death, caused many to hunt for him. Locals looked upon him as a modern day Robin Hood.

According to my father, Sam's spirit returned to haunt the lead company every year. When the month of August approached, St. Joe amassed absurd amounts of office supplies. Closets, storage rooms, desks, and filing cabinets bulged to capacity. Then, before the month ended, a noticeable dwindling of the supplies occurred. No one ever admitted having seen Old Sam's ghost but Sam Hildebrand got blamed all the same.

Coincidentally, when school opened the morning after Labor Day, many children of St. Joe employees strolled the hallowed corridors of school toting ruled note pads, number two wood pencils, tape, paper clips, rubber-bands, and rulers identical to the type St. Joe used. My father said management never asked questions, probably fearful of Sam's reputation. As he said, there was a hint of justice in it. The "haves" had indeed assisted the "have-nots."

* * *

Historically, St. Joe kept abreast of technological innovations. Generally, when something became available which would

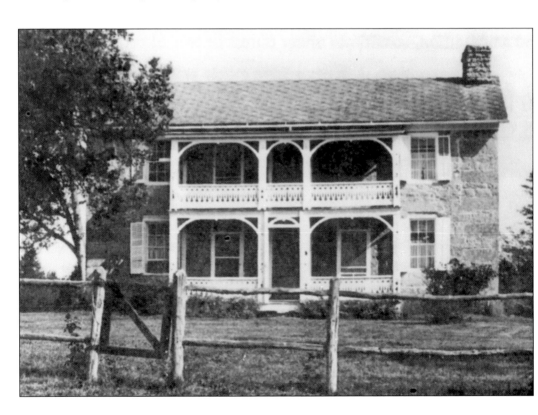

Rebuilt, the Hildebrand house as it appeared in the mid-1960s.

St. Joe maintained accounting offices on the second floor. This building sits on top of the first 1869 mine shaft.

enhance production, lower costs, or benefit employees, St. Joe hesitated little. They bought immediately. However, for reasons never explained to me, the company did not rush out to buy air conditioning systems for their stuffy offices.

Founded in tradition, male office staffers wore long-sleeved dress shirts and ties to work. Women wore dresses, or a blouse and skirt. On hot summer days, fans hummed from every conceivable space: floors, tops of filing cabinets, or mounted on walls. Windows were thrown open. Towels were frequently placed beneath wrists to keep sweat from dampening ledger pages. Book notations were made by fountain pens, fine tipped ones so numbers could squeeze neatly into tiny rectangular blocks. Constant breezes created by the fans and opened windows generated a real need for numerous paperweights. All

those problems got compounded when working on the second floor. Heat filtered up stairwells and into spaces already sweltering.

One particular building housed the bowling alley on its ground floor, but accountants and bookkeepers on the upper level. Unlike other structures which had been built 30, 40, or 50 years earlier, cross ventilation in this building was impossible. The interior design had too many walls for private offices. Employees grumbled about the heat almost daily. By the time they finished work at 4 p.m. every afternoon, each one looked like a Titanic survivor, dripping in their own sweat.

An engineer with St. Joe heard of their misery and took pity on them. He thought about the situation and then formulated a brilliant solution. That particular building sat directly on top of the original 1869 mine shaft. Temperatures below ground varied slightly,

hovering mostly around 57 degrees. He calculated that should a small opening be managed into the old shaft and connected to air ducts, natural cooling would be obtained. His idea circulated through management and they agreed. Vent ducts would be inexpensive, and poking a hole through the sealed shaft would be simple. Work began. Finally, the announcement came on a Friday that everyone had worked their last day in sweat. Connection to the shaft would be completed on Saturday which would allow two days for the floor to cool.

Long-sleeved men and women in dresses arrived Monday morning to a new environment. They entered a floor which felt cool and clean. Ledgers were removed from the vault and everyone went happily to work. After lunch hour, some noticed a slight tackiness on chairs, desktops, and cabinets. Even papers seemed moist. Still, the environment had improved so dramatically that no one dared complain. At 4 p.m. all the ledgers were returned to the vault, lights went out, and the staff departed for home.

Tuesday morning proved disastrous. Chair seats and desktops were more than just tacky, they were quite wet. Ledgers removed from the vault were opened to find the ink had smeared to blotchy messes and were almost illegible. The engineer and management had forgotten to consider that air underground contained a high percentage of humidity. By Wednesday the pipe entering that old shaft had been sealed over, windows were opened, fans hummed, and paperweights kept ledger pages from flapping in the hot breezes.

* * *

Upon her graduation from high school in 1939, my mother worked as a switchboard operator with Southeastern Telephone. She remained in that position until just before I came along in 1946. When both my sister and I had reached the ages that we could be left at home by ourselves, she resumed her operators job with Southeastern. That would have been in the late 1950s. In those days, calls got made by picking up the receiver and waiting for an operator to come on-line. Either the phone number—three digits—or the name of the party one wanted to call were given. I watched my mother and the other operators pull and release cords, criss-cross jacks to connect and disconnect calls, and observe monitor lights on that switchboard until I got dizzy.

Those women had other responsibilities besides tending the switchboard. They provided accurate time in two manners. One could pick up the receiver and ask the current time, or one could wait for the noon siren to blare. Operators had control of a siren mounted on top of the bank building. At noon each day they sounded it for one long blast. When told by the police chief or fire captain, the operator sounded the siren three consecutive times. This alerted volunteer firemen to report to the engine-house immediately.

On one particular occasion the morning had been anything but typical. Hectic activity kept the operators unusually busy to the point that they missed the big hand crossing the little hand on 12. Within minutes the entire board resembled a Christmas tree with callers wanting to know if the siren had broken or if their clocks were incorrect. Already stressed to a level where she wanted to scream, my mother pushed the button to make the siren give only a little blast but about 10 minutes late. Even though it was only a brief little blast, the board nearly overloaded with calls about the time. Never did she play another prank with the siren again.

On those times when the operator had to sound the alert for a fire, activity at the switchboard again increased. Curious people all over town wanted to know where the fire was located. Frequently, by the time enough volunteers had driven to the engine-house, pulled on their fire-fighting

gear, opened the garage door and started their drive, dozens of residents had already gathered at the fire scene. By the time the fire-truck arrived, a warm and friendly crowd cheered them on.

Not until a couple of years into the 1960s did our town become modern with their telephone equipment. Going to rotary phones required much time and planning. Homes and businesses had to obtain new equipment with dials. That in itself took many months. At that same time is when the new oval shaped phone with an illuminated dial was to be introduced called the Princess Phone. Mom brought home keychains with various colors of the phones which would soon become available. My sister and I really thought we were something because we possessed the first replicas in town. Mom also brought a paper home one evening with the various possibilities for our first three digits, or prefix, when we transferred to the rotary system. She read the list of possibilities and our entire family agreed that only one sounded regal enough for Bonne Terre. Our selection was FL8, the FL standing for Fleetwood. The prefix we liked best was selected by the telephone employees, and to this day the 358 prefix remains for Bonne Terre.

When the dial system finally came into existence in Bonne Terre it was welcomed by most residents with enthusiasm. But for our family it did destroy one great benefit. Conference calling today is quite common. In those days, no such thing existed: almost. My mother could arrange a call to be placed to distant relatives during slow periods such as late evenings or Sundays. She could call a relative in Independence, for example, and my grandparents could talk on their phone, we would use our home phone, and Mom would be on the switchboard. With rotary dial, the local telephone office closed and we no longer could use our conference connections.

* * *

The New York corporate headquarters of St. Joe once hired a new executive. Like many officers with their New York office, this individual possessed absolutely no background in mining. He was probably a bean counter, some C.P.A. with letters a mile long behind his name impressive only to other bean counters. Anyhow, someone in New York suggested the young fellow make a trip to Bonne Terre to see what mining entailed.

The assistant superintendent got saddled with escorting the Yankee, a responsibility he cared little about. Perhaps a week before his guest arrived, the assistant made a trip underground which happened with much regularity. One of the workmen showed him a pneumatic hammer which had gone mad. A peculiar problem required just the right know-how to operate the device. One handle contained a lever which normally was squeezed to activate the machine. A release of the lever stopped it. However, this one had developed a quirk. Squeezing the lever turned it on, but releasing the lever kept it operating. Only a swift kick on the main cylinder disengaged its jarring.

When the new executive arrived, he got whisked around the central office, mill, lab, and other buildings, all the while being educated by the assistant superintendent as to company history and functions of various pieces of equipment. The Yankee carried an arrogance which the assistant found quite obnoxious. After lunch, the two boarded the "cage" which lowered them into the mines. A small work crew had assembled to answer questions the new employee might have and to demonstrate various mining procedures. By coincidence, the usable but contrary pneumatic device just happened to be nearby. Whether the assistant had requested its presence cannot be overlooked as a real possibility. The new person insincerely inquired about certain items more as an expectation rather than true interest. His arrogance began to rub even the workers in a wrong way.

The assistant stepped to the jack hammer and picked it up. Motioning to the Yankee, he suggested his guest should have some hands on experience to impress the big guys in New York. This placed the fellow in a difficult position. Refusing would make him appear frightened. With no other alternative, he walked toward the assistant and said he'd be glad to give it a try. Told to hold on tight and squeeze the lever, the man proved just how well he could follow instructions. He pulled on the lever and the hammer began to jolt him hard. No one told him that releasing the lever would have no effect. When he let go of his grip on the lever the contraption continued to shake him up and down. The assistant allowed two or three minutes to pass before stepping forward and placing a hard kick on the main shaft to turn it off. Finding it difficult to hold back his great pleasure of getting even for the guest's arrogance, the assistant offered a big slap on the younger mans' back and said, "Welcome to St. Joe Lead. Now you know what people must do to fill your wallet with paychecks."

The lead company had their safety department in this structure. Safety was always top priority.

St. Joe used this as their carpenter's shop. The first Masonic Temple was upstairs where a mural still graced one wall in the late 1960s.

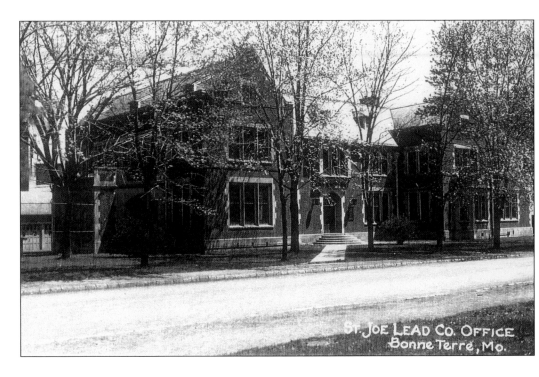

These central offices of St. Joe Lead is where the division manager and upper management were housed.

This old building was used for many purposes by the company, mostly for bookkeeping.

Once a bank, it failed during the Great Depression. St. Joe bought it and placed their traffic department in this stone building.

St. Joe built this as a swimming house for employees and their families.

* * *

The crushing process of raw rock created loud noises and dust so thick it could nearly be cut with a knife. Yet, the fineness of the crushing allowed a rather simple process to separate plain rock from lead, zinc, silver, and other mineral traces.

While the various minerals were sorted and readied for the smelter, the rock had turned to sand, or chat. Huge quantities had to be discarded around the clock and it made sense to form a single dumping site. Mule pulled carts made dozens of trips every 8-hour shift from the mill, across the main entrance of town called Benham Street, to what then was an open field. Once electricity arrived, a conveyor belt supported by concrete pillars alleviated the need for

carts. Increasing in height as it neared the field, the conveyor dropped tons of chat daily. Over many years that waste heap grew to gigantic proportions. When St. Joe called a halt to this dumping process, the chat pile had a length in excess of 400 yards and a width of over 100 or more yards. Estimates for its height reached 150 feet. From State Highway 67 the gray mountain drew stares from passing motorists. Often times, motorists took the exit ramp, entered town, and inquired at the school, a gas station, or some other type of business as to what the purpose of the pile might be and what created it.

St. Joe constructed their golf course adjacent to the large pile, although they allowed sufficient distance to separate the

two, at that time. With each passing decade, however, the chat lowered in elevation but spread in girth. Winds, rain, and other elements, coupled with residents climbing to its top, shifted chat toward the ground which broadened its base. Eventually, the golf course had one hole which abutted the chat pile. Hundreds of times each summer, golfers threatened to take pictures of the fairway, green, and chat dump, then submit their photographs to golfing magazines.

They imagined the caption would have read something like "World's Largest Sand Trap."

Some residents thought the chat pile seemed to be an eye sore, but no one will deny it became Bonne Terre's most distinguishing monument. Motor bikes, four wheelers, and other motorized forms of play have challenged its steepness and height. Much of the southern end was used to mix concrete for the newer four lane Highway 67.

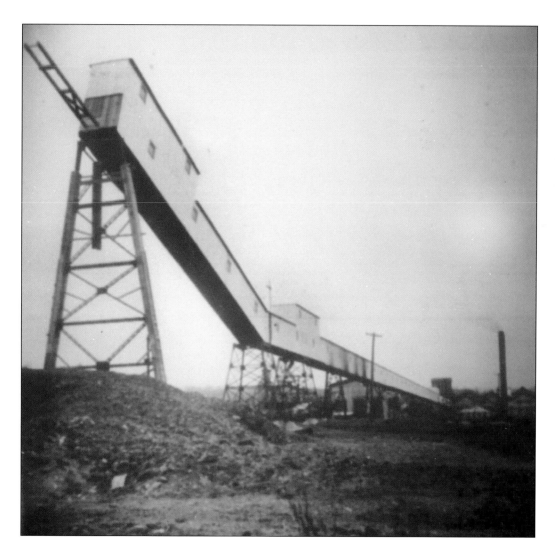

This conveyor carried chat to a vacant area beginning c. 1916. (Courtesy of the Wilke Collection.)

The chat pile, Bonne Terre's most visible memorial, shows footprints and tire tracks for those daring enough to climb to the top.

The golf course with the world's largest sand trap at its side.

Rumors always circulated that one company or another intended to reprocess the chat because minerals were there for the taking. Nothing ever happened. In truth, there would not be enough valuables found to pay operating costs.

Those few who found the pile unsightly soon cooled their criticism after a tornado swept through Desloge in the 1950s. The twister ripped a swathe through the heart of that town, then turned to make another devastating pass. Its funnel ran directly into a similar chat pile which hurled sand all over Desloge. But the monster heap of waste materials pushed the twister high into the air and away from town without inflicting further damage. That gave many folks a new-found respect for the mountain of sand.

The pile was so distinct in size compared to its surroundings that even the Air Force made use of it. While I served with that military branch in Plattsburgh, New York, we were a member of the Strategic Air Command (SAC). Twice a year, SAC Headquarters in Omaha, Nebraska, would arrive unannounced and initiate what we called an Operational Readiness Inspection. The B-52 bombers had to be airborne within minutes, then fly designated courses as instructed by the inspection team. In order to rate the crews on various abilities, part of the exercise included practice bombing runs simulating a series of bomb drops. An unmarked railroad boxcar equipped with radar monitors would be stationed near a target. The B-52 crew would have to find the target and trigger a device in the plane which emitted a signal toward the ground. Equipment inside the rail car could then determine how close the simulated bomb drop had been to the target area.

In 1967, shortly after our base had completed one of those three day inspections, I had the assignment of disposing all classified materials used during the bombing scenarios. I properly declassified the material and filed appropriate paperwork to base headquarters. Next, I began to gather the documents to have them shredded when I accidentally stumbled upon the flight plans. Being curious, I studied the maps and soon recognized the Mississippi River. Looking more closely, I discovered the arch in St. Louis had been a target, and then to my amazement I followed the flight path to an X which happened to be the chat dump in Bonne Terre. Therefore, another dubious honor the town can rightly claim is having been bombed repeatedly by the Air Force.

Chapter 4

ONCE A YEAR

The combination stage and basketball court magically transformed into a royal setting in 1963.

Based upon my personal observations and experiences, it is not necessary to possess special training to evaluate the health of a community. An accurate diagnosis can be reached by watching just how active residents are in their public school system. A parochial school exists as a community within the community. But the public system is at the will of the whole. If my thinking on this is correct, Bonne Terre's school never missed one day for illness.

The school year began on Tuesday after Labor Day. Within a week, the senior class received individual packets containing magazine data. An age-old tradition of selling subscriptions or renewals served as a foundation to raise money for the class trip to New Orleans in May. There seemed to be a routine most class members followed. The immediate family became victims first, extended family came next, followed by the entire neighborhood. Within two weeks, all sales ended. Checks and cash were counted for accuracy, subscription/renewal forms analyzed, and the profits tucked away in a special bank account.

Toward late September, all four upper classes prepared for the largest fund raiser of the year. The event went by the name of Mother's Club Carnival. It probably should have been called Community Social based on the support of locals. Each class had two weeks in which to raise money and construct a float in keeping with a parade theme. Bonne Terre soon got inundated by students attempting to raise funds by nearly any means possible. Some methods never changed: raking leaves, washing cars, painting porches, installing storm windows. Different, more creative ways seemed to emerge as well: popcorn sales at the town square on two consecutive Saturdays, pizza sales and home delivery (we had no pizza restaurants in the entire county at that time), or selling homemade fudge door-to-door.

Constructing floats took place during evening hours. Each class attempted to keep its site for float building a deep dark secret but never succeeded. Water balloon fights, always in good fun, established territorial rights. Students even attempted to maintain secrecy regarding what their floats would be. That seldom lasted more than a couple of hours the first night. Still, such juvenile acts and expectations continued from one year to the next. Going through the motions seemed to be the real objective.

The Mother's Club Carnival culminated most often on the second Saturday of October. By then, trees had started to turn colors and the most gentle hint of sharper temperatures prevailed. From dark, recessed areas of closets came long-sleeved shirts, sweaters, and head scarves. A dampness in the air could be sensed but not actually seen. Yet, the heavy air kept smoke low to the ground from burning leaf piles. That fragrant aroma of autumn permeated all of Bonne Terre.

By mid-morning of the appointed Saturday, the school area assumed an aura of great panic. Determining where to place each parade unit had been worked out long in advance. The problem on parade day tended to be locating all the units. Their varied arrivals to the school created havoc for planners. Rearranging required patience and a good sense of humor.

Somehow, the madness and utter confusion abated. The first unit, our city fire engine, would sound its siren. The blast quickly rose in octaves to a loud shrill. Then it slowly dropped to a sub-level bass. Grade school children sat on hoses atop the engine and let out screams of excitement. The parade had officially begun.

One block north of our high school is where people started to observe this annual event. Ancient trees spread their long thick limbs in an arched fashion out over the street. This created a multicolored corridor under which the parade passed. At intervals behind the fire-truck came bicycles festooned in crepe paper, balloons, and plastic streamers. Further back were horses with western clad riders, antique automobiles, king and queen

For the 1963 Carnival, the author helped construct the senior float, a life-sized elephant of chicken wire and tissue paper.

candidates in convertibles, the floats, and our school band. The final unit supposedly was the police car, but I remember it being a mixed assortment of stray dogs.

The parade turned left at the end of Allen Street. It had to. The street pavement ended. One block west and another left turn put the parade on an uphill stretch of Division Street. From that intersection until the town square had been reached, spectators grew in number. They cheered each unit regardless of beauty, precision, or mass confusion. Applause and whistles bolstered participants egos although most recognized the realities. Regardless what efforts can be made, floats made of chicken wire and tissue paper look like chicken wire and tissue paper. The band played and marched with gusto but because its make-up consisted of junior and senior high members both with little time for joint rehearsals, the sound could only be so good, the individual lines only so straight. Yet, none of this appeared to have much bearing on those watching. They saluted the spirit of a hometown event, and that spirit is what counted most.

Restaurants and grills enjoyed a brisk business when the parade concluded. People sometimes had to stand in long lines for 30 minutes or more before seating became available. Afterwards, local merchants kept busy as many folks lingered to look, visit, and make purchases. This special day was intended for pleasure, not rushing back home to tasks requiring manual labor.

When the sun started its descent and settled low over distant western hills, all attention moved to the combination junior/senior high buildings. Adult volunteers, many dressed in 1920s costume, supervised games for all ages. A great-uncle of mine liked to don the same clothing each year. He wore a white shirt, tie, straw hat, and liked to carry a bamboo cane. He entertained young children by swaying his vaudeville cane like a clock pendulum. When the arc lengthened, he would twirl it like a baton. For as long as I can remember, my great-uncle managed an

old-fashioned cakewalk. I've dropped many a dollar in his straw hat for the privilege of walking around a classroom until music stopped. A quick glance to the floor to see what number I landed on would be followed by a glare his direction. Impatiently, I waited for him to draw a number from a coffee can, hoping it matched the numbered square I stood on. I've taken home several cakes, some quite good, some average, a few for the garbage can. I always thought myself lucky. Now I have this gnawing feeling that perhaps someone in a straw hat sporting a bamboo cane ensured my good fortune.

Classrooms converted into game-rooms for all sorts of low-risk opportunism. There were dart throws, ring tosses, fish ponds, apple bobs, and souvenir shops. Above all that, the greatest draw, year after year after year, would be the car smash. A local auto-body shop donated a car and towed it to a location just outside the junior high building. For money, and with the aid of a sledge hammer, anyone could invoke damage to the junker. The front windshield always went first. Even after every window had been broken, mirrors and chrome trim ripped off, doors creased, and the trunk caved in, kids still paid for the privilege of trying to inflict some sort of unique damage to it just one more time.

Besides all the various games, car smashing, and trinket sales, booths sold sandwiches, desserts, and non-alcoholic beverages. Most popular of all was hot or cold apple cider, spiced or plain. For the daring, sticky caramel apples proved just the thing.

In late evening, when the carnival atmosphere began to wane, people casually strolled into the high school auditorium. The stage, which also doubled as our basketball court, had been magically transformed into a royal setting. Sheer fabrics were draped behind platform risers where two regal chairs awaited occupancy. An emcee would appear from behind curtains, express appreciation for such a large gathering, and

offer the official news that another carnival had met its goal. That brought a round of applause.

When silence returned, the lights dimmed and a piano could be heard. The emcee, in a tone of suspense, announced each king and queen candidate. Girls in formal gowns and boys in dark suits slowly stepped down the aisles to oohs and aahs. Each one gracefully ascended steps to the stage area, found their designated place, and faced the audience. After all eight were introduced, the emcee would remind the audience that votes had been determined by which class raised the most money. Then, the names of the new king and queen would be read. Seniors won almost every year, but there were some exceptions. The unexpected could occur when a candidate happened to have a wealthy relative who paid dearly for some chore to be performed. To a standing ovation, the newly crowned couple of royalty assumed their thrones. The carnival officially ended.

Not many days afterwards, another ritual involving school children commenced. Merchants offered their shop windows for budding artists hoping to be discovered. In short time, clear glass turned into dark, mysterious paintings depicting Halloween scenes. Headless horsemen, witches on brooms, ghosts peeking from behind oddly shaped trees, and tombstones inscribed with RIP graced storefronts. Late on Halloween night, hundreds gathered under the single light on the town square. Trick-or-treaters paraded past judges. Divided into age categories, small monetary prizes were awarded for best costume, scariest costume, and most original. At long last, announcements were made as to winners in the painting competition. Safe and harmless, the goblins quickly dispersed, headed to the comfort of waiting beds to dream about the next year. In a day or two, most eerie creatures disappeared from windows and retailers glass fronts sparkled like new. The only reminder of Halloween could be found on sidewalks. Splotches of window paints created by careless artists remained, but time, foot traffic, and rain would soon cause even those to vanish.

From Halloween until Thanksgiving, Bonne Terre buzzed with activity. Most trees had released their hold on leaves. Final rakings and burnings at curbsides were held. Window screens came out and were replaced by storm windows, usually washed first with vinegar and waded newspaper. Pilot lights were lit on gas furnaces and the heating system tested. Opened front and rear doors on comfortable autumn days indicated the home heating had just been checked. Dusty fumes emitted from idled ducts filled the house with an odor not welcomed by most. With storm glass over most windows, the only way to clear the unwanted smell meant opening all possible doors.

Thanksgiving break seemed to signal abrupt changes. Winter clothing, often times reeking of mothballs, replaced fall attire. Basketball, the ruling sport of our area, shifted into high gear. And, the sights and smells of Christmas appeared everywhere.

Shortly before Thanksgiving, city workers strung lights across many streets in town. Simple, unadorned, normal sized bulbs of alternating color were all we had. Not all of them always burned but it made us no difference. Perhaps that simplicity is what made it seem like Christmas. Homes did not go overboard either. Outdoor lights along overhangs and around doorways sufficed. My favorite was a two-story federal-style home which placed a candle and small wreath in each window. Two green floodlights on the front lawn projected just enough hue on the houses white siding to give it elegance. Cedar wreaths with red bows on church doors were appropriately tasteful.

My uncle owned and operated a jewelry store for nearly 25 years. Absurd as it sounds, I learned from him the secret of a successful Christmas shopping season from a retailers point of view. Bad weather. That's all. I spent a great amount of time in his shop,

This simple Christmas scene was displayed by the author's great-grandfather. It was one of the first yard displays in St. Francois County.

This shop once belonged to the author's uncle which was a jewelry store for a quarter century.

probably more than he preferred. He once told me that if Friday, or Saturday, or both days after Thanksgiving proved cold, snowy, rainy, or at least overcast, chances for a good retail holiday season existed. With uncanny accuracy, he could total up sales for those two days and predict within a few hundred dollars his entire amount of Christmas sales. Inclement weather seemed to get people in the buying spirit. Warm, pleasant weather made Christmas seem too far away to stir excitement.

Winter months filled the school auditorium repeatedly to overflowing for many events. Until 1961, our high school basketball games got played on the 3/4-sized court which doubled as a stage. Two choir concerts and an equal number of band concerts took place. And, an event called Capers served as a signal that another educational year was almost over. Students from all grades were selected to perform various skits. Sometimes funny, sometimes serious, sometimes funny when not intended to be, Capers again drew crowds similar to the Mother's Club Carnival.

Over the years, that stage hosted Lewis and Clark, George Washington, Abe Lincoln, William Jennings Bryan, Fats Domino, the Everly Brothers, and many other personalities. Bobby Darin even splish and splashed in a tub of water. Ironically, those notable figures looked much like students. The grand finale came with introductions of our Capers king and queen candidates. Once more, the stage became a temporary palace. Young ladies and gentlemen stepped down the aisles and onto stage. The emcee announced two names and an ovation erupted. Capers of another year concluded with the seating of royalty.

Seniors presented a play in the spring, then came their New Orleans trip followed by graduation. That old auditorium held many events and hundreds of people attended each one. Rich or poor, powerful or powerless, learned or not, all people were alike. Bonne Terre truly supported its school with vigor.

Chapter 5

ONCE A CENTURY

Bonne Terre School Band led the parade to our town square. The author's sister is the baton twirler on the extreme right.

As we prepared to turn our calendars to read 1964, Bonne Terre casually prepared for a centennial celebration. I use the word "casually" with much intention. First, except for cities of great size, a centennial celebration is typically a one day only affair. A committee is formed to make plans, obtain publicity, and recruit volunteers as needed. Their efforts, although important and recognized by some, go mostly unnoticed. They perform their tasks out of love of the community, not for notoriety. Second, a minor concern arose as to just who's centennial it would recognize: St. Joe Lead or Bonne Terre. St. Joe had been formed and operated in the area since 1864. That could be proven. As for Bonne Terre, only a stretch of the imagination could make 1964 the 100th year of the town. The postal service had not officially acknowledged it as a town until 1868, and even then it spelled it Bontear. Third, our townspeople didn't appear to be much in a party mood. St. Joe had ceased mining in Bonne Terre three years earlier. Company offices remained there but even they would eventually be relocated to Viburnum in Iron County. St. Joe had discovered a higher grade of ore in that location and could use modern methods of machine mining rather than mostly by hand. People questioned their personal future as well as that of their community.

I don't know that it is possible to exaggerate the pessimism which prevailed at that time. I worked at the golf course during summer months and heard many conversations not intended for my ears. People from miners to upper management seemed at a loss for answers to questions such as: What would become of Bonne Terre? Would the town start a death spiral? What about all the land St. Joe owned? Perhaps the most stinging concern, what did Bonne Terre offer that might attract new businesses? Away from the golf course I listened to my family share similar concerns. The topic was voiced at my uncle's store. Thankfully, members of

the centennial committee saw hope. They never let their faith in our town diminish like a candle blowing in strong winds.

When spring approached, the committee announced what plans had already been laid. There would be a beard and mustache contest. Those wishing to compete should stop shaving. Period costume contests would be held for men, women, and children. The committee hoped to publish a booklet which could be sold to offset expenses they incurred. Informational, the booklet would contain a history of the community along with photographs from the past. A punch and cake social might be arranged, and finally, a community dance outdoors.

Our high school vocal director recruited four boys to form a barbershop quartet. I was included. Several organizations indicated an interest for our group to entertain them. Our rehearsals had to be conducted before school, after school, and nearly any time all of us could unite. It made no difference whether we had 10 minutes or an hour, we needed that practice. Perhaps by fate alone, after weeks of faltering and struggling, everything suddenly gelled. Meanwhile, vests and straw hats were secured. Whether we sounded good or not, at least we would look good.

The group performed for several organizations that spring and summer. A garden club, chamber meeting, and others seemed to enjoy our programs. At least no one ever booted us out the door. We had moments of great harmony and times we failed to meet our own expectations. Overall, we did ourselves proud.

When the big day arrived for the entire community to celebrate, attitudes were slightly warmer, more hopeful. That morning the square in town was jammed with hundreds of people bent on enjoying a grand time. A "jail" housed inmates; people who failed to wear anything resembling period clothing. Of course, for 50¢ or $1 they bought their freedom. Those participating in beard, mustache, and costumes, had to

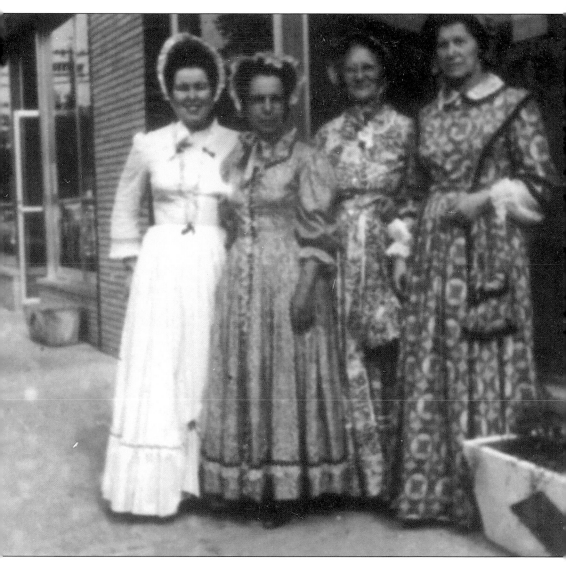

Pictured here are four women in 19th-century costumes, for the centennial celebration of 1964. (Courtesy of the Wilke Collection.)

The entry gate to the Superintendent's House, which was built in the early 1880s.

sashay before a panel of judges. Winners of various categories felt proud but restrained their inflated egos. No loser is known to have pulled a gun or kicked like a mule.

The punch social had been finalized and promised to entice a large crowd. To make the social even more tempting, the committee had arranged the perfect setting. Late in the 19th century, St. Joe had built a two-story structure on a hill at the southeastern corner of town. Set among tall, gracious trees, the purpose of the building was to host New York visitors from corporate headquarters and for formal functions the Division Manager deemed appropriate.

A private, single-lane drive intended for horse and buggy, veered off one end of Oak Street. A stone wall on the right side of the drive elevated in height as one neared a gate. The wall stopped at that point. From there to beyond the building, a well manicured lawn was maintained by a resident caretaker. A tight loop for turning around at the building had to be maneuvered with some caution. Inside the building, a rich comfortable atmosphere welcomed guests. From the entry level, two or three steps were necessary to descend into a room most often called the common, or ballroom. On either side were two dining rooms. All three of these areas contained built-in bookshelves with glass paneled doors and were packed with books dating to the early 1800s. From the common area were French doors leading to a screened porch. On clear days the small community of Desloge could be seen from that vantage point. In the rear of the main level was an

A spacious cottage was built in 1880, to house corporate officials from New York.

enormous kitchen, complete with a walk-in refrigerator and dumb-waiter.

The second story could be reached by climbing a beautiful dark stained staircase. Sleeping quarters occupied the entire floor. Several bedrooms, some with private baths, some without, were completely furnished with luxurious beds, chairs, desks, tables, and lamps. A few of the rooms contained doors which lead to a second screened-in porch.

Of much interest to me was a particular bath which had a shower. A copper pipe connected to the main water lines had been bent into a perfect circle. Small holes drilled at perfect angles formed an even spray when the water was turned on. Thus, long before shower heads were common articles in hardware stores, St. Joe had developed its own form of shower. What also made that interesting to me, as well as the bookcases, stairway, and ornate woodwork, is that it showed the skills of a very special person in my life. One of my great-grandfathers served as a master carpenter for St. Joe at the time the building had been constructed. Much of what appeared in his own house could be seen at this building. St. Joe called it the cottage. Because its intended purpose served only a select few, not many residents of Bonne Terre had seen more than its exterior. They now had a rare opportunity to step inside.

To provide additional charm, horse and carriage rides to the cottage could be taken for a nominal fee. Rides started at the old train depot which was located not more than two blocks from the cottage. Drivers

A stone wall borders this narrow lane that was intended for horse and buggy, which leads to the St. Joe Cottage.

This is the Superintendent's House, made up mostly of stone, as it appeared in the early 1970s.

outfitted in long tails and stovepipe hats assisted riders into their carriages. With only a slight tug on the rein, a jerk indicated the horse with blinders had received the message to move along. Crossing the railroad tracks jostled riders up, down, and sideways, even though wooden-spoked tires had rubber treads. The carriage crawled up a slope permitting riders the chance to inspect the second least accessible structure in town—the old Superintendent's House. That title had been dropped years earlier for a more modern title of division manager. Yet, to the older generation, that original name would always be used. Constructed in the 1880s of stone, later added on to in the rear with mostly frame, the two-and-a-half-story house exuded prominence and security. Sitting amid 7 acres of gentle sloping land, the entire property was lined with a white board fence. An entry gate, wide enough for only one vehicle, led up an asphalt drive lined with stones as gutter works for water removal. At the opposite end of the block came the exit gate. Besides the imposing house, a barn, multi-car garage, dog kennel, swimming pool, and caretaker house were within the fenced boundaries.

I knew the house reasonably well at that time. The occupants had invited me there on two different occasions. What I could not possibly have guessed, however, is that four years later my mother would marry the division manager and vice president of St. Joe and become tenants of the house. For nearly nine years, until the company moved its operations to Viburnum, that old Superintendent's House contained a very familiar face and I spent many days and nights within its charming atmosphere.

Using terms we assigned during the period my mother lived there, I will offer a quick description of its interior. From a large entry foyer, a pair of pocket doors led to a living-room on the right. The living-room stretched approximately 30-feet in length and probably 18 in width. A working fireplace presided at one end and faced tall windows at the opposite end. So large was this room that my mother discovered it required three sofas, several chairs and end-tables, plus two coffee tables just to make it not appear like a funeral parlor. Left of the entry hall were a combination library/music room, dining room with fireplace similar in size to the living-room, and a sun-porch which served as a television room. Beyond the foyer were a breakfast nook, wet bar, and a spacious kitchen. From a grand staircase in the foyer, or a set of narrow stairs from the breakfast area, one ascended to the second floor. That level contained five bedrooms, an office, and a second television room. Stairs from the TV room led to what had once been a maids quarters. Imposing as it might sound, I assure those who never walked inside the house that it contained much warmth for those who dwelt in it and those who came as guests.

Riders in the carriage followed that long board fence until it ended. At that point the horse slowed as it pulled carriage and passengers up the gentle drive toward the cottage. Maneuvering the loop, the carriage came to a stop by the front doorway. Inside, a long table covered in linen held a punch bowl and cake. Dry ice in the silver bowl formed vapor which ascended a couple of feet and then vanished. People mingled about, touring both levels and the porches and even spreading out onto the terraced back lawn. It was a time for socializing, blissfully enjoying a style of life one finds mostly in dreams, imagining it was your personal house and all those other people were your invited guests. When ready to depart, folks gathered in the loop area. The next arriving carriage would return passengers to the depot.

The final activity of the celebration occurred that evening. The paved lot of a former used car dealership had been encircled with bales of straw for seats. Live music for dancing blared over loud speakers and out across the lighted asphalt. Young and old alike could find music of their pleasure. Nearby vendors sold apple cider and other refreshments. As

A side view of Superintendent's House, with the author's mother overlooking the area around her garden.

midnight approached, the crowd dwindled and the final song played. Bonne Terre's centennial celebration had reached its grand finale.

Regardless if someone participated in all the events of that special day, just one event, or none at all, was not the determining factor of success or failure. The greatest significance had to be measured by what happened afterwards. Noticeably absent from that party-like atmosphere was the lead company. By design, St. Joe had chosen not to participate. It had lent the cottage but that was all. Like a parent, St. Joe had raised its child from infancy. Time had come for the offspring to be self-sufficient. The company knew Bonne Terre could survive on its own. The community now had to recognize the same thing. The Bonne Terre centennial proved that attitudes can change because people began to find hope without any need of assistance from the lead company.

Chapter 6

REFUSING DEATH

Bonne Terre Memorial Library was dedicated in 1905. Constructed of Bedford stone, the interior is appointed with oak shelving and floors. An 1830s grandfather clock stands inside the entrance foyer.

In the 20 years I lived in Bonne Terre, the lead company endured one strike by its hourly employees. Poorly timed and partly out of frustration, union members walked out in 1963 for what would be a six-month work stoppage. The Bonne Terre operations had already ended and St. Joe had tons of lead stockpiled along the Mississippi River at Herculaneum. The company could sell from its inventory for months without paying needless wages except to its salaried employees.

After a few short weeks, most strikers had to accept government commodities for mere survival. Rumors abounded that special government inspectors lurked about town, checking garbage containers to ensure those commodities were used by only those authorized. My grandparents did not favor the peanut butter so my immediate family would carry the silver can inside a paper sack to our house. When empty, we put the can back inside a sack and returned it to my grandparents trash container for disposal.

My grandfather and many of his peers soon realized that by striking, St. Joe could make higher profits. When ready to concede some of their original demands, employees made arrangements to renegotiate with management. Both sides reached an agreement and the strike ended. However, St. Joe would move with great speed to

The high school building as it now appears. In 1967, it merged with Desloge to form the North County School District.

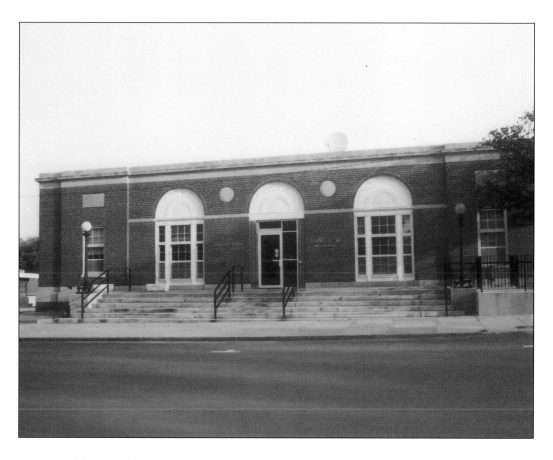

The Post Office Building in Bonne Terre has not changed in the last 60 years.

purchase land in Iron County where new mines would emerge.

Back on their daily jobs, workers heard talk that other mines in St. Francois County would be closing sooner than expected. Lead reserves in Iron County were larger and richer. New methods of automation could be employed there which would mean a reduction in the number of workmen needed to extract ore. Even though estimates of 75 years worth of minerals existed in the old mines, modern procedures were impossible to perform in century old caverns only a few hundred feet below surface. As the months passed, St. Joe confirmed many of the rumors. Within 10 years, all mining and office personnel would be relocated.

From the strike and until the centennial,

Bonne Terre's future did not look very bright. Soon after the gala event concluded, however, the chamber of commerce and St. Joe Lead began to advertise in national publications, hoping to entice interest for other businesses to locate in our little town. In due time their efforts paid dividends.

A tour of Bonne Terre today, nearly four decades after I left it, finds many familiar sights still around to remind me of that once glorious past. Our wonderful old library built of Bedford stone, oak interior, and a grandfather clock dating to the 1830s, still welcomes young and old patrons. The Mississippi River and Bonne Terre Railway depot of 1921 is well maintained. Churches, hospital complex, and some iron buildings formerly belonging to St. Joe are still there

A former dairy, which made delicious ice cream.

This is the clubhouse at the Lead Belt Golf Club, where the author worked for six summers.

The author's great-grandfather served as St. Joe's Master Carpenter. This photo was taken on his last day of work in October 1941.

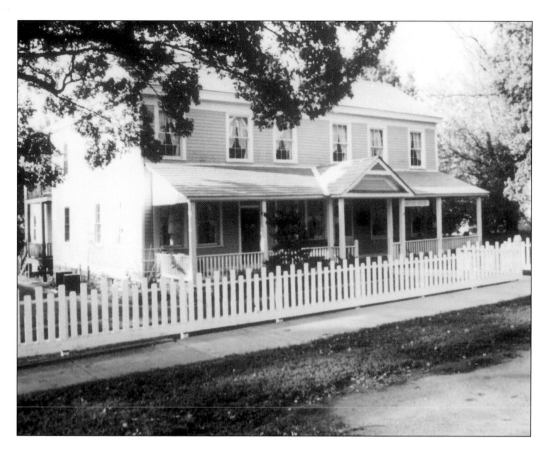

Built as a hotel, the Shepard House is presently home to the Chamber of Commerce.

and are used for numerous purposes. Yet, by necessity, Bonne Terre is not the same town in which I lived and grew to embrace.

What we term as progress today has created an atmosphere completely different when compared to the past. Specialty shops of bygone days have given way to chain stores where everything under one roof can be purchased in one stop. The former retail district has empty buildings where merchants once conducted teeming businesses. Yet, a lake development of many decades has lured outsiders to relocate, a new prison is about to open, and the population continues to increase. Bonne Terre has proven that it intends to remain on the map.

I have been privileged to tour four underground operations in my lifetime. It happened that I was the last non-employee to enter the Federal Mine in Flat River. The drifts, those lateral tunnel areas which stretched in many directions for miles on end, were very narrow. Small trains ran on rails which were worn smooth and shiny from decades of travel back and forth. They hauled ore to a shaft where it would be hoisted to the surface. An entire city of its own lies underground. I toured the first mine opened in Viburnum shortly after it opened, and later, the mine in Bixby which was named after my step-father. Both of the latter two are so different when compared to mines in the old Lead Belt. Ceilings and walls of the drifts are smooth like plastered walls of houses. Trucks of extraordinary size and power maneuver back and forth as though they are

on interstate highways, not underground. Offices resemble their counterparts on the surface, except they don't have windows to an outdoor view. Paneling and modern furniture make it too easy to forget that one is over 1,000-feet below ground. Instead of one man holding an iron rod while another one strikes it with a sledge hammer to bore holes for explosives, a machine with multiple "fingers" will bore numerous holes in seconds. To me, the environment seems too sterile.

The first one I ever toured as a youngster, and have since revisited many times, is the original Bonne Terre mine. There, in 1869, rough talking, hard drinking, brawny men, equipped only with crude tools and dim lights, forced their way by inches into the depth of Mother Earth. Pillars of great diameter remain untouched, stacked one atop the other on every mining level for support so the town will not be swallowed into obscurity. It was there where mules, at one time Missouri's most valuable livestock, lived, worked, and died so a town could exist, families could be raised, and all could be remembered.

Buildings of the former Bonne Terre school system remain, but the school merged with Desloge in 1967 to form the North County School system. Today, the words of the former Bonne Terre School song must live in memory alone. The opening lines of that song have much more meaning now than they did when I sang them in my youth. The song began, "Mid the hills of Old St. Francois in Missouri's richest spot..." To me and others, Bonne Terre will always be Missouri's richest spot. And, how true was that pompous white and green sign at the entrance to town. Bonne Terre is good earth...and good people.

The oldest cemetery of Bonne Terre is located one-mile north of town. Few know of its existence. The oldest known grave dates to 1860.

The Bonne Terre Historic Mine Tour buildings offer visitors a sense of the early days in Bonne Terre.

An engine, which pulled ore cars underground, is displayed for visitors to inspect.

The author is seen here in a hardhat, as he prepares to go 1,200 feet underground.

BIBLIOGRAPHY

Blackwell, Robert. *Bonne Terre: The First Hundred Years*. Bonne Terre Centennial Committee. 1964.

Dearing, F.H. *A Historical Sketch of Bonne Terre*. Private Publication. 1933.

Houck, Louis. *The Spanish Regime In Missouri* (2 volumes). Chicago, IL: R.R. Donnelley & Sons Company. 1909.

———. *History of Missouri* (3 volumes). Chicago, IL: R.R. Donnelley & Sons Company. 1908.

St. Joseph Lead Company. *A History of the St. Joseph Lead Company* (For Private Circulation). New York, NY. 1892.